THE BLAKE BYRNE COLLECTION

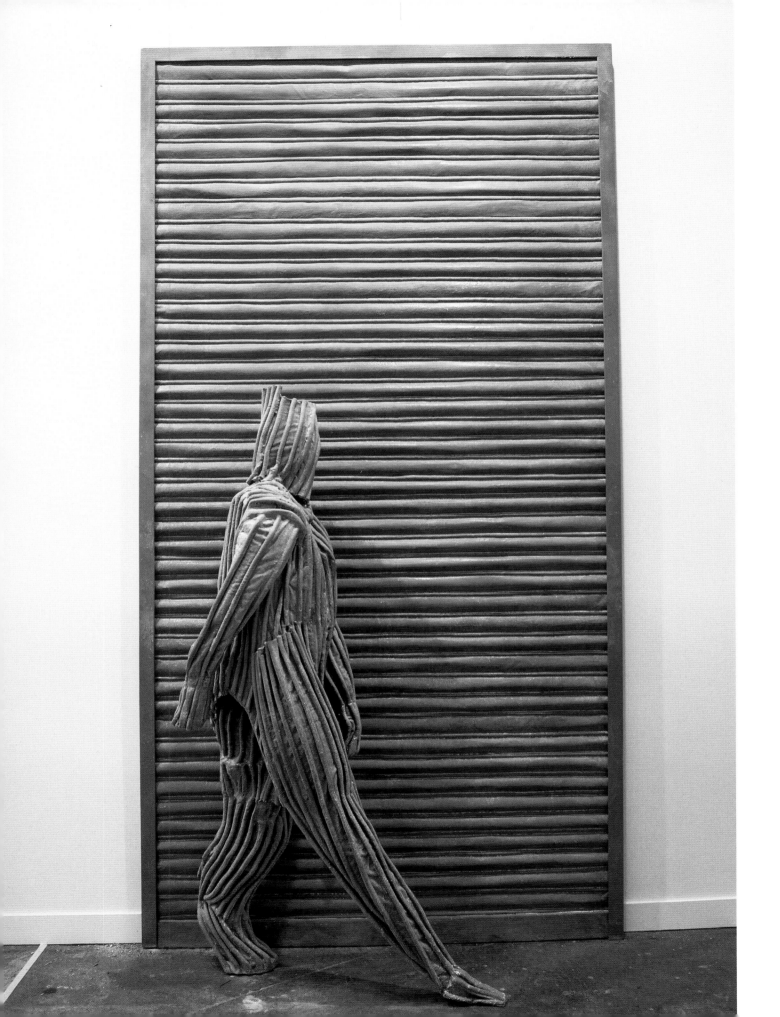

THE
BLAKE BYRNE
COLLECTION

THE MUSEUM OF CONTEMPORARY ART, LOS ANGELES

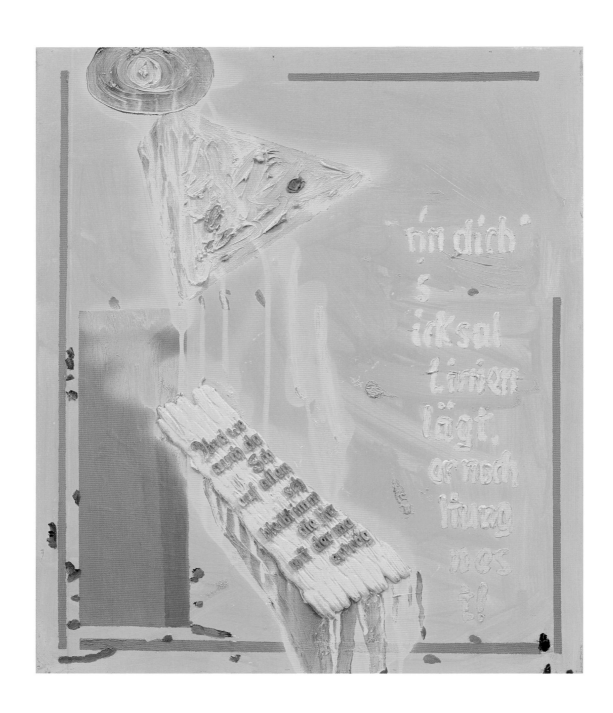

MARTIN KIPPENBERGER *Form und Farbe*, 1982

CONTENTS

FOREWORD

Throughout its history, The Museum of Contemporary Art, Los Angeles (MOCA), has been honored by the extraordinary participation and generosity of numerous collectors in the community. Among these invaluable supporters are those whose personal dedication to contemporary art underscores and propels their commitment to championing artists, fosters the growth of cultural institutions, and enriches the artistic profile of the city—and who by example have inspired others to do the same. MOCA's renowned permanent collection remains one of the most remarkable and treasured achievements since the museum's founding in 1979 and is a testament to the exceptional relationships we enjoy with our collecting community—including such visionary patrons as Beatrice and Philip Gersh, the Lannan Foundation, Barry Lowen, Count Giuseppe and Mrs. Giovanna Panza di Biumo, Rita and Taft Schreiber, Scott D. F. Spiegel, Joel Wachs, and Marcia Simon Weisman, all of whom have made significant contributions to the museum's holdings.

Blake Byrne's exceptional donation of 123 works by seventy-eight artists, the largest single gift from a private collector in MOCA's history, is one such contribution. With his gift, Blake has notably expanded our permanent collection with a broad range of important works by local, national, and international artists from the late 1950s to the present. Blake is a keen champion of contemporary art and artists, as well as a passionate, energetic, and thoughtful collector. A MOCA trustee since 1999, Blake has been a prominent member of the MOCA family and an active participant in the Los Angeles community since the late 1980s. It is MOCA's privilege to present this exhibition and catalogue in celebration of Blake's generosity and to honor his exceptional contributions to our community. "The Blake Byrne Collection" highlights selections from the gift, giving us a glimpse of the impact the works will have in the context of our permanent collection long after this exhibition is over.

On behalf of the museum, I would like to thank those who have facilitated bringing this gift into MOCA's holdings, as well as those who have contributed to the realization of this exhibition and publication. We are grateful to our Board of Trustees, and in particular we acknowledge the special efforts of Cliff Einstein, chair; Willem Mesdag, president; Susan Bay Nimoy, vice-chair; Dallas Price-Van Breda, vice-chair; Vivian Buehler,

chair of the Acquisition and Collection Committee; and Jennifer Simchowitz, chair of the Drawings Committee. Our heartfelt gratitude goes to MOCA Trustee Michael Sandler and Brenda Potter for their very special support of the exhibition and publication, which is a touching testament to their close friendship with Blake. Additional funding has been generously provided by UBS.

Since MOCA's announcement of the gift in December 2004, enormous effort has gone into preparing the exhibition and publication. We extend our sincerest gratitude to Barbara Schwan, executive director of the Skylark Foundation and registrar, curator, and advisor for the Blake Byrne Collection. Barbara has generously facilitated innumerable requests for information and images and ably handled all the other details that inevitably make up a project of this scale. We are also indebted to the work of Astrid Greve in Blake's office. As well we extend our appreciation to Blake's children, Jocelyn Elsbrock and John Byrne, for their generous support.

I wish to thank the entire staff of MOCA for their assistance and participation. I want especially to recognize the key role that Paul Schimmel, chief curator, played in paving the way for this historic acquisition, due in great part to his close relationship with Blake. I also wish to thank Senior Curator Ann Goldstein and Assistant Curator Michael Darling, co-organizers of the exhibition, for their thoughtful contributions to the project, which was realized in close collaboration with Blake. MOCA's entire senior curatorial staff contributed to the development of the gift. I thank Curator Connie Butler, Curator of Architecture and Design Brooke Hodge, Associate Curator Alma Ruiz-Furlan, and Curatorial Associate Rebecca Morse. Curatorial Assistant Gabriel Ritter has also been a dedicated member of the project team, serving as a central liaison between the Skylark Foundation and MOCA. For his invaluable counsel and guidance, special thanks are due to Assistant Director, Board Affairs, Ari Wiseman. In addition, I am grateful to Director's Office and Board Assistant Shannon Ernster and Executive Assistant Angie Duncan for their special efforts.

The arrangement of the shipping of artworks has been ably and carefully handled by Associate Registrar Karen Hanus-McManus, who also assisted photographer Brian Forrest with documenting many of the works. The beautiful installation was made possible by the expertise of Director of Exhibition Production Brian Gray; Chief Exhibition Technician Jang Park; Exhibition Production Coordinator Sebastian Clough; Technical Manager, Exhibitions, David Bradshaw; Lead Exhibition Technicians Shinichi Kitahara and Barry Grady; Exhibition Technicians Monica Gonzalez and Jason Pugh; and Administrative Assistant Annabelle Medina.

The realization of this superb catalogue is due to the tremendous efforts of our exceptional publications department, led by Director of Publications Lisa Mark. Our deepest gratitude goes to her, as well as to Senior Editor Jane Hyun, Editor Elizabeth Hamilton, and Administrative Assistant Theeng Kok. For its exquisite design, we thank designer Peter Willberg. Others at the museum who deserve thanks are Director of Development Thom Rhue and his staff for their critical funding support; Education Program Coordinator Aandrea Stang for assembling an exciting slate of public programs associated with the exhibition; former Director of Public Relations and Marketing Katherine Lee and Public Relations Coordinator Heidi Simonian for so successfully orchestrating the media outreach; and Creative Services Director Olga Gerrard and her team for developing a dynamic visual identity for the exhibition.

Finally, our profound gratitude goes to Blake for his warm and active participation. Further evidence of the exceptional generosity and philanthropy that infuses his entire life, Blake has chosen to bestow us with this extraordinary gift on the occasion of his seventieth birthday. We could not be more deeply honored and touched by his munificent offering to our permanent collection, his continued and cherished support of MOCA, and his remarkable contribution to Los Angeles.

Jeremy Strick
Director

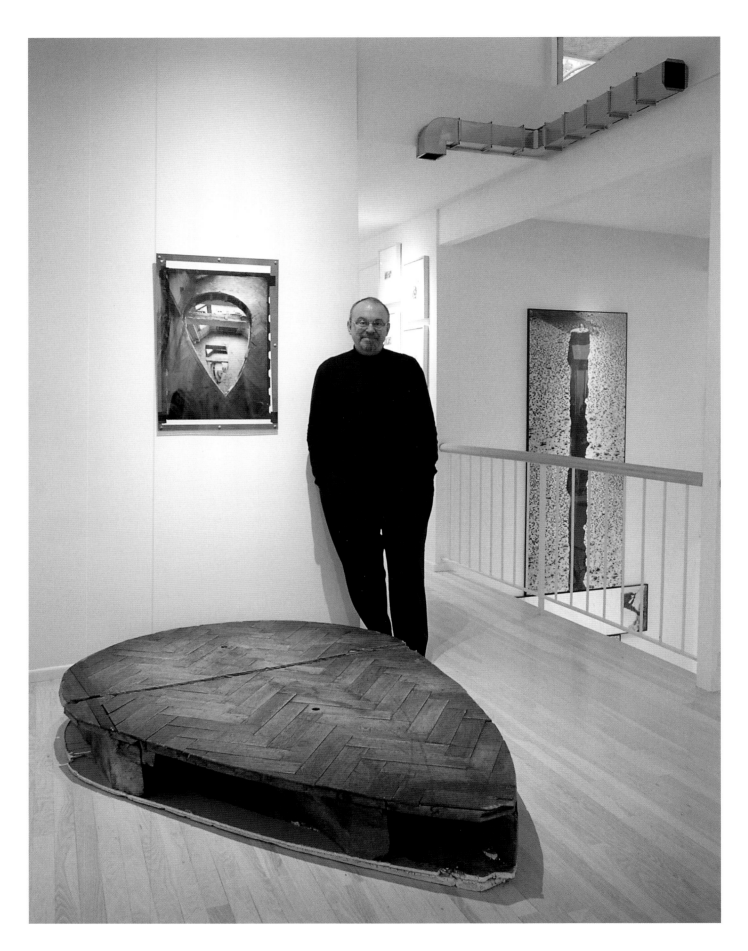

Blake Byrne at home with Gordon Matta-Clark's *Office Baroque* (1977), Rita McBride's *Servants and Slaves (domestic)* (2003), and John Baldessari's *Mesa* (1990), Los Angeles, 2005

INTERVIEW WITH BLAKE BYRNE

Ann Goldstein and Paul Schimmel

Paul Schimmel: You've talked about your gift to MOCA as a gift to L.A. Why?

Blake Byrne: Why Los Angeles? Well, having lived so many places, Los Angeles is the place I love the most. And after loving L.A., I came to love MOCA. I'm proud of how this art community has grown, proud of the collection that we have at MOCA, and what incredible strides we have made in a relatively short period of time. I've always *loved* this city. I lived here for about six months when I was five and then my folks moved here again—to Riverside—in 1953 when I was a freshman at Duke University. I spent the spring semester of my junior year at University of Southern California and then did graduate work there. Throughout my career in broadcasting I came to Los Angeles every June for the affiliate conferences. Over the years I made friends and renewed friendships. So, with all those things put together, L.A. seemed a natural choice.

PS: I sometimes think people who come here, who choose to be here—like you—have a deeper appreciation for the culture of this community. In some ways it's a community really made of outsiders who somehow feel embraced and taken in by this city. When you came here, was that the case? That this was more home than any other place for you?

BB: Coming back to L.A. in 1989 was like returning home. A friend of mine remembers when I came back in '89, he asked if I was glad to be back in L.A. and I said, "Absolutely, because by the end of the next century this will be the greatest city in the world." Since 1989, look at what's happened in this community. We have the Getty Center and Disney Hall, all the museums and institutions have grown, we have one of the top philharmonic orchestras in the world, our opera society has created this magnificent entity, and we have MOCA—one of the finest contemporary art collections and programs in the world. From 1989 to 2005, we're already well on our way to being the greatest city in the world.

PS: 1989 seemed to be a very important year for you; not only did you move back to Los Angeles and make a commitment to this city, but it also seems that at that point you became very active as an art collector. I was looking at the dates of your acquisitions over the

years and, although you had acquired art before '89, something happened late that year.

BB: The first major acquisition for me was in June of 1988, and that just got me so excited. I had been living in New York and had bought some prints from Jim Kentner, who took me around to introduce me to some other gallerists. One day, when he took me by Jack Tilton's gallery, I said: "My lord, how in the world does one learn about art? There is so much to learn," and Jack said something to the effect of, "I have a booth at the Basel art fair. It's the greatest art show in the world and if you come over there, spend a couple of days, and walk around and look at the booths, you'll start to develop your own taste buds." That was phenomenally good advice. I went over and, with a budget of $60,000, I bought my first seven pieces. That was the beginning.

So by 1989 when I moved to Los Angeles, I'd already started collecting when I met Margo Leavin and bought a Mark Lere from her—which stands by my pool and is one of my favorite pieces. Then I met Rosamund Felsen, and I bought Mike Kelley's *The Monitor and the Merrimac* from her, which was also an early acquisition.

Ann Goldstein: You have spoken about this gift as a gift to the city and about how you hope that it will enrich the city and inspire others, but what has this collection done for you personally? Why do you collect?

BB: There are lots of different reasons. I think having really wonderful, beautiful, and thought-provoking objects around you is just so incredibly stimulating mentally and intellectually. I've had people say to me, "Oh my goodness, I can't believe you're going to be seventy…How do you stay so young?" And I tell them, "I think a lot of it is collecting contemporary art." As a collector, you're always carrying on conversations with young, bright, curious, research-oriented, delving, digging intellects *through the objects*. And pieces change. They don't always say the same thing to you. When you're up they say one thing, when you're down they say something else. Then other people come to your home and have a totally different idea of what a piece means. Art's a moving target, which is so incredible.

In the process you meet other collectors and see their collections, and you can't help but compare what they collect with what you collect. In the late 1980s and

early 90s, there was not nearly the frenetic competition that there is in today's art world. I think it would be tough to start today, but that's because I started eighteen years ago. Those who start today are also having a wonderful time.

PS: There are many people who would have said that the time you started, in the late 80s, was very tough. In fact, it wasn't that long after you started collecting that the market went through a tremendous contraction, which you bought right through. A lot of people who started collecting in the late 80s gave up when the early 90s came along, but you actually redoubled your efforts.

BB: Absolutely. I started collecting Juan Muñoz, Christina Iglesias, Marlene Dumas, and Richard Tuttle when I went to that first Basel art fair in 1988, and I continued to collect those artists. I didn't want to stop—it just didn't occur to me.

PS: I was going to ask you about Jack Tilton. I first heard about you through Jack, Tony Cragg, and Juan Muñoz.

BB: Right. And Marian Goodman was right upstairs from Jack Tilton.

PS: Jack's interesting because he's very old school yet he's obviously very engaged with new art. I met him when he first worked for Betty Parsons at her gallery. What brought you to Jack? Had you wanted to collect and all of a sudden had the income to do it?

BB: Absolutely. My former wife and I started collecting during our honeymoon in Paris; then after we divorced twenty-five years later, I started fresh. I started collecting Russian icons, but I realized I couldn't just collect icons. I did not want to spend my whole life going into archives trying to determine whether or not something was from 1832 or 1796! That wasn't my forté. That was in '86–'87. And then I began collecting prints, most of which I later sold. I went from that to my first trip to the Basel art fair in 1988.

Today I tell everybody what Jack Tilton told me about going through every booth at Basel and seeing what your taste is; then you can start to follow the auctions, go through the catalogues, and collect books. Buy the catalogue of every museum show you go to. And then when you find an artist you like, buy catalogues of their earlier shows that you've missed. Between books, auctions, and physically going to galleries and museums and art shows, I must see 10,000 pieces of art a year. And that's not that many. It's not like I'm doing that every day of my life. It's just how much crosses your path. I mean, Paul, Ann, you must look at 100,000 pieces of art a year.

AG: I think it is important that one spend the time looking at art—that one take that time. It is important to see the works in person, to go and personally meet people, to have discussions, and to seize opportunities to meet the artists.

Blake, I had a question for you in terms of your history. You have talked about Jack Tilton and about the influence and generosity of certain people like him who are dealers. Now you are a role model to people, to younger collectors, to your peers, and so on. Who were your role models as collectors? Were there certain collectors who really inspired you?

BB: When first married, we were influenced by a Duke classmate, Peter Fischer, and we bought several pieces at the Sculpture Center, which he introduced us to. Then in Providence, Rhode Island, we were inspired by Bruce Helander, then dean of students at Rhode Island School of Design. When I started collecting in New York, it was for such a short time that I really didn't end up with any collector role models there. It was when I came to Los Angeles that I first started meeting other collectors. I think one of the first people I met was Bea Gersh. She invited me to join her and Paul for lunch. As a result, I contributed my first work to MOCA—a piece I bought from Marian Goodman: Tony Cragg's *Branchiopods*.

Bea was kind enough to invite me to her home and, just walking through her home with all those incredible pieces, I just thought, "Oh! Maybe someday I could have two or three pieces like this." So she was really the first person. And someone else who just overwhelms me as a collector is Joel Wachs. What a great collection he has. And how many years did he collect on a very small budget?

AG: Yes, Joel assembled an extraordinary collection with just one-quarter of his income as a Los Angeles city councilman. Many of his works were acquired very early

in the artists' careers—in some cases, the first works they sold. And over the years he has gifted many of those works to MOCA.

BB: He was always there. You ran into him in galleries all over town. Always friendly, always open, always talking about things he was excited about.

PS: He's very good at sharing. But not all collectors are. You are one of the collectors who enjoys turning friends on to collecting, who talks about a great show he just saw.

BB: And then there's Tom Peters. He has a catering business here in Los Angeles and he started catering for art gallery openings. He would often trade his services or part of his services for a work of art, and goodness knows how many pieces he has. He has always lived in very modest apartments in Los Angeles where pieces are stacked against the wall twenty deep. But he knows where every one is. He is unbelievable. And what a great collection. Tom loves art and is very, very sharing. And then there is Alan Power, whom I met through Jack Tilton. Alan lives here in L.A. and is, again, just so sharing and very knowledgeable—so much more knowledgeable about art than I'll ever be.

PS: Clearly, other collectors have been very influential for you. With this major gift from your collection coming to MOCA, what are your hopes for it? Beyond enriching MOCA with its great quality and diversity, what message is it sending to the next generation of collectors, artists, et cetera?

BB: My hope is that this gift inspires others to do the same. That's a given. I was laughing with a friend just after the gift was announced and I said, "Well, if my fantasies come true, my eightieth birthday ought to be the celebration and the honoring of those whose collections came into MOCA after my gift." And I meant that. Wouldn't that be a wonderful way to celebrate and honor those people who have also given?

AG: It is also a great pleasure and honor for artists to see their works given to museums—no matter what stage they are at in their careers. That's something I would never underestimate.

BB: Obviously, without the artists, we don't have a museum. I really envy the two of you—and I think even especially Ann, because she's married to an artist, she really knows how to talk to artists. Since I've been associated with MOCA, she's been a key person who is always there for the artists. And every museum should be so lucky. You know, for a long time, I didn't really want to get to know the artists. I was concerned about being objective and being influenced positively or negatively by their personalities. There were a couple of exceptions—Rita McBride became a very good friend early on—but it took me a while to feel comfortable with artists. Rita gave me the courage to move beyond my insecurities about artists. Bruce Helander was there at the beginning as well.

PS: Many collectors feel like you did, very uncomfortable getting to know artists because they feel this kind of responsibility to be objective. I think it's unusual how many artist friends you have and the depth of feeling they have for you. Now you seem almost unusually committed to getting to know artists, as both a responsibility and a pleasure.

BB: I think living in Paris has helped. Artists who come through Paris often want to see the collection, and I've gotten to know artists who live in Paris—probably even more than in Los Angeles because L.A. is so much bigger than Paris. Paris is small enough that there aren't that many collections that are accessible to people. And Paris is so close to Cologne that I've gotten to know some artists there, like Kai Althoff. And, through Rita and Glen Rubsamen, I've gotten to know others like Marlene Dumas and Robert Birza in Amsterdam and—until his death in 2001—Juan Muñoz in Madrid.

AG: As a private collector, the works you have acquired over the years have been not only conceptually challenging but physically complex—and increasingly so into the present. For example, with Steve McQueen's video installation *Drumroll*, you acquired a work that you couldn't possibly install at home. What brought you to do that?

BB: It was shot in midtown Manhattan, right where I used to have an apartment. And I met Steve and I really appreciated what he was trying to do. When I was

about to buy it, I had never spent that kind of money on a video in my life, and I said, "Okay, I'm ready."

PS: Around that time I noticed that you were beginning to think of MOCA when buying certain pieces. When you bought the Stephan Balkenhol, when you bought the Steve McQueen, you were already buying them with MOCA—a public institution—in mind.

BB: Well, I think that's true. I have those kinds of thoughts in the back of my mind. Absolutely.

PS: How did you get into television? What's your background there?

BB: I got into it sort of by accident. I was going to go to work in finance for Texas Instruments in Nice, France. I was getting an MBA from Columbia at the time and, during negotiations with TI, Columbia's placement director called me and said, "CBS is coming out to interview tomorrow, and I know you're about to conclude a deal with TI but I have one slot open and I want CBS to come back next year. So would you just fill it in and act like you're interested?" And I said, fine. I guess he thought I was a big actor. CBS had a ten-month training program that put you through all of the financial areas (which was natural with my background) and also all of the programming areas. You would work on four different shows, travel to different television stations. I mean, it was the best training program in America for any company. At the end of the meeting I was just fascinated. I thought, "Wow, what an opportunity." And that was it. My dad was a radio pioneer, so that was an influence as well.

PS: Of course, MOCA has an extensive history with people from the entertainment industry—including Douglas Cramer, Barry Lowen, Gil Friesen, Phil Gersh, Scott Spiegel, Taft Schreiber, Beth Swofford, Dean Valentine, among many, many others. It is remarkable that people always say, "Oh, the entertainment industry doesn't do anything for the visual arts," and yet, throughout its history, MOCA has benefited enormously from the entertainment industry.
So, where were you after CBS?

BB: I went with smaller companies. I was a sales representative and then moved to Portland, Oregon, where I was with Chris-Craft, the boat company; but they also owned TV stations. After six years we moved to Providence, where I was with the Outlet Company, a local department store in Providence that owned WJAR-TV, and then to Dallas/Fort Worth with LIN Broadcasting at KXAS-TV. After I left LIN, I took some time off and then joined Disney when they bought KCAL. That was the first really big-name company I worked for after CBS. We started the *Prime Nine News*, which is a three-hour prime-time newscast; we were the first over-the-air station in the country to do that. I then went into "retirement" again for a second time. I came out of that by starting Argyle Television in 1992 with two partners, Bob Marbut and Ibra Morales. Argyle merged with Hearst in 1997, which was really the hundred-pound gorilla merging with the mouse. Their chief operating officer decided he was not going to retire. That was supposed to be my job in the newly merged company—so I decided I would! That's when I started the Skylark Foundation, bought an apartment in Paris, and decided to reorganize my life. I became more intense about art, and I started to get involved with MOCA and the Duke University Museum of Art.

PS: Tell us about the Skylark Foundation. What is it?

BB: I would love for Barbara Schwan to describe it, because Barbara is the executive director of the Skylark Foundation half time and half-time registrar, curator, and advisor on the Blake Byrne Collection.

Barbara Schwan: The Skylark Foundation is the Byrne family foundation. The board members are Blake, his daughter Jocelyn and her husband Tim Elsbrock, and his son John and his wife Charlotte. We give to about fifteen organizations a year, and our focus areas include services for women, education, art and humanities, services for gay and lesbian youth, services for the elderly, and environmental protection. We serve the communities that the family members live in, so we support organizations in Los Angeles; in Charlotte, North Carolina; and now in Santa Fe, New Mexico, because Jocelyn and Tim just recently moved to Santa Fe. The grants range from about $5,000 to $20,000 and focus on areas that the family is passionate about. What's exciting to me is that

we tend to give to organizations that are relatively small—where a $5,000 to $10,000 grant can make a big impact. A lot of them are very grassroots: one organization we serve in Los Angeles is called JUICE [Justice for Uniting in Creative Energy]. It's for kids that don't fit into the normal social/school situation; they have programs that teach hip-hop dancing, DJing, mural painting—it's fantastic. It's very creative, very grassroots, and very small. And then on the other hand, we're involved in combating a big environmental problem in North Carolina that's affecting clean water and air. So it's very diverse. My job is to represent the family and look into causes that they're interested in, to review the proposals and help them decide how they want to exercise their philanthropy.

BB: Barbara stays in touch with the organizations more closely than we do, obviously. At the same time, I'd say we're starting to play a more active role. Because we don't have tons and tons of money, we can focus. For the most part we give to organizations that don't have million-dollar dinners, where $10,000 really makes a difference. For instance, this year, for the first time, my son went out and helped an organization in North Carolina with their development efforts and it was just great. Establishing a sense of philanthropy with your family just can't be beat.

PS: Clearly one of the things the foundation has done is allow you to teach your children about giving back to the community. The MOCA gift is a gift to the community, the foundation gives back to the community. Where does that come from in you?

BB: Probably my mother. She was always heading a volunteer organization, always helping a friend in need. She was bright, with tons of energy, and was always doing things for others, like starting organizations. She started a thing called the "Gift Corner" at the Riverside Community Hospital. She was just very, very generous with her time and effort.

PS: So it's a family tradition.

AG: A lot of the work that you acquire has social content, a provocative nature. Not everything in the collection—your collection is actually quite geographically and chronologically diverse, as well as having a broad range of media and content—but there is a consistent aspect in which artists express their relationship to the world and their feelings about their state in time and place. How is your collection a reflection of your own outlook on life and your position in the world?

BB: I think, though I'm a very opinionated person, other people's opinions really do matter to me. Other people's thoughts help me arrive at conclusions that allow me to be opinionated, if that makes sense. And I change my mind. I'm not ashamed to say, "I think I've made a mistake there. I think it should be this way." I think that's one reason art that reaches out appeals to me. There's work in my collection that says, "This is another culture, and don't forget that there's more than one culture out there. There are lots of them."

AG: Looking at the gift itself, it is an incredible, diverse, rich group of works that is going from your personal collection into an institutional collection. For us at the museum there's also a transformation as we start to think about these works within an institutional context. What are your thoughts as this work moves into an institutional collection? Are there certain works in your gift that are markers for you, that are landmarks for you?

PS: One work we probably both have in mind is the sculpture by Gordon Matta-Clark. He is an artist we greatly admire, and until now we haven't had a major work by him. Where did this sculpture come from?

BB: I walked into Gabrielle Maubrie's gallery in Paris and saw this piece of floor with the photograph and went, "Oh, my lord." I didn't know the artist at the time but it had a strong emotional impact on me and certainly influenced my thinking process in relation to other conceptual works.

AG: It's certainly a powerfully emotional work: cutting into a building, opening it up historically and almost viscerally, and excising parts of it before it disappears.

BB: Obviously, I had a strong positive reaction to the Matta-Clark. Gabrielle then showed me a book with photos of work he had done with buildings in Paris. The idea of going in and cutting up old buildings and creating

relationships with it—I went home and I couldn't get it out of my head. I called her up and I said, "I'll take it."

PS: It's interesting that, although he comes from a conceptual background, you're quite right, his work is very emotional. It's also very political. Your interest in communication does seem to be embodied in this piece. And yet with no history, no knowledge of the artist, where he came from, you went in and it just struck you.

BB: That shouldn't be such a surprise because art is communication. If it talks to you, you talk back to it, and you create this little story. That's what the piece did for me. It's like sharing thoughts from other cultures that make you rethink your own. MOCA's curators are people who look at art, who have obviously different backgrounds, different thoughts. Paul and I have laughed about the fact that MOCA has such a diverse group of curators and that everybody doesn't always agree, and wouldn't that be awful if they did. I want to see what you will do with the collection because that will give me a new look at all those things as well.

PS: I want to get back to something I was asking earlier. On your first prophetic trip to Basel, you acquired works by Marlene Dumas and Juan Muñoz, both of whom you collect in depth. There is a very emotional expressive quality to their work. And yet you also have conceptual works by Joseph Kosuth and John Baldessari. In thinking about the relationship of these works to one another, I sense that, first and foremost, a work of art has to just strike you in your heart.

BB: Oh, no ifs, ands, or buts. And I'm an emotional, expression-filled person. So obviously I'm drawn to that kind of work. I can't stop looking at things that express an emotion, even when that emotion is hidden. A piece might appear static, but it represents an emotion. I could probably find an emotional reason for almost anything in my collection.

PS: You were talking about how artists, or people in general, can change your mind about things. It all does come together if you think about it. Your politics have been a very important part of your life, including your intense engagement with the recent presidential election and the John Kerry campaign. You have really made a very strong commitment to political change, to bringing the kind of emotion that you have to a larger public forum. Do you see a crossover between politics and art?

BB: Politics and art do come together, but what interests me are those candidates who want everyone to be free to think, change, and do what they want. Politics and art in my world come together absolutely because contemporary art is free and open, and full of ideas, and that's what politics should be. In politics you have to be ready to build some form of consensus, but in contemporary art you don't have to reach a consensus.

AG: Artists respond to people with open minds, and that's certainly something you've demonstrated.

BB: Well, it is who I am. Yes, I think so. It's what I want to be.

Los Angeles, 20 December 2004

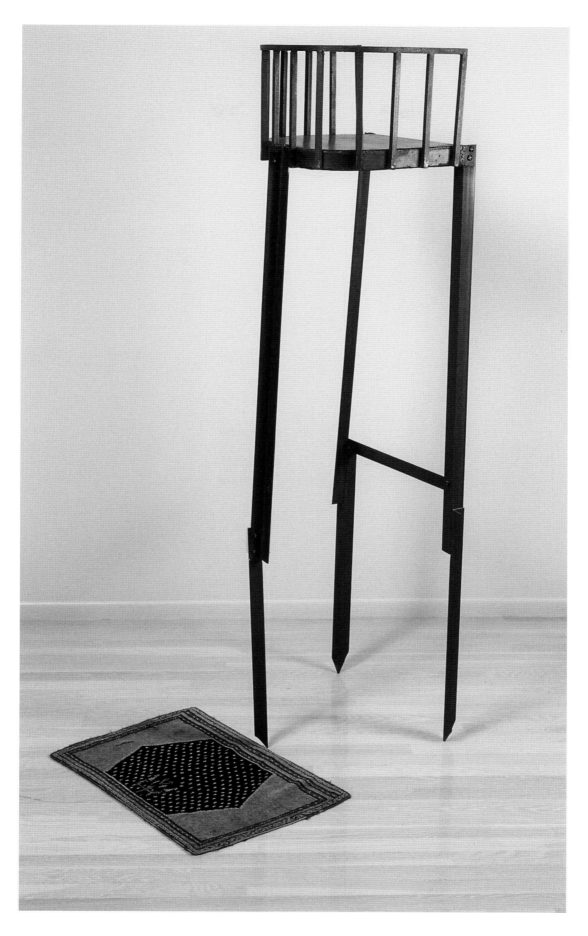

JUAN MUÑOZ *Minarette*, 1989

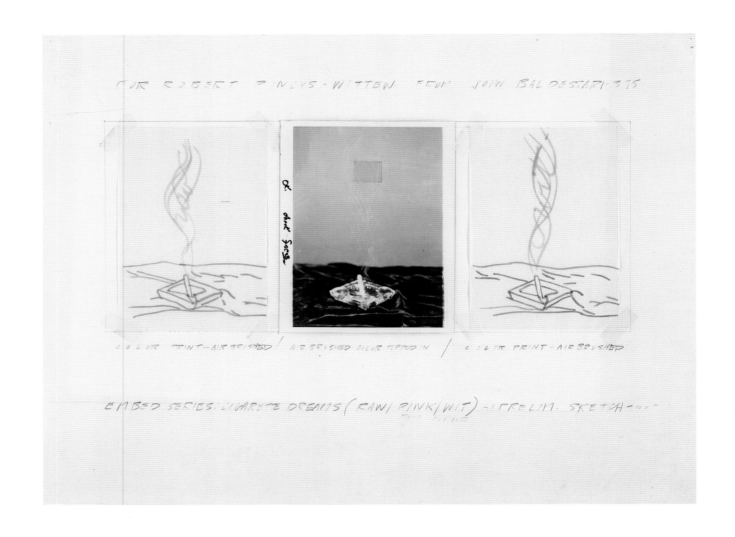

JOHN BALDESSARI *Cigarette Dreams (Raw/Pink/Wit)*, 1975

THE BLAKE BYRNE COLLECTION:
RIGHT AT HOME

Michael Darling

Though Blake Byrne had been looking intently at and acquiring art from various periods for over thirty years, his focus shifted decisively to cutting-edge contemporary art in 1988. Since then, Blake has dedicated himself to learning more about the art of his time and developing the confidence and discernment necessary to build a collection that is both expansive and focused—one that possesses extraordinary range while maintaining strong commitments to certain artists. Over the past seventeen years, he has assembled a collection representative of the central concerns of the late twentieth century, while collecting works by Juan Muñoz, Rita McBride, and Marlene Dumas that span their careers. His forays into contemporary art have been divided nearly equally among Los Angeles, New York, and Paris, making his perspective unusually broad. The balance of breadth and depth in his collection mirrors that of The Museum of Contemporary Art, Los Angeles (MOCA), such that the works he has gifted seamlessly integrate into the museum's existing holdings while enriching them unequivocally. Byrne's gift to the museum of 123 works of art by seventy-eight artists extends his legacy to the public, exposing MOCA's audience to artists that were not previously represented among the 5,000 or so works already in our possession.

Arguably, the gift's strongest dimension is how it enables MOCA to strengthen collections of works by artists who have been inseparable from the museum's own history. Artists who have had solo exhibitions or significant roles in important group shows at MOCA, and those the museum has already committed to through the acquisition of their work, are prominently included in the gift. Works by John Baldessari, Robert Gober, Felix Gonzalez-Torres, Douglas Gordon, Richard Hawkins, Mike Kelley, Joseph Kosuth, Gordon Matta-Clark, Paul McCarthy, Juan Muñoz, Claes Oldenburg, Gabriel Orozco, Sigmar Polke, Ed Ruscha, Jim Shaw, Cindy Sherman, Richard Tuttle, and Andy Warhol are all included in the gift, often by more than one major example of their work.

For instance, John Baldessari's career—central to the history of the Los Angeles art scene and the subject of a retrospective exhibition at MOCA in 1990—can now be represented more fully thanks to two extraordinary examples from the Byrne gift: the early photo-and-text piece *Cigarette Dreams (Raw/Pink/Wit)* (1975) and the monumental photo work *Mesa* (1990). *Cigarette Dreams*

(Raw/Pink/Wit) is a study for a photo triptych in which the words "raw," "pink," and "wit" seem to form in the smoke rising over cigarettes placed in ashtrays. The triptych is part of the Embed series, which features similarly subliminal photographic interventions using airbrushing or double exposure. *Mesa* clearly derives from the earlier experiments, stretching photographic "truth" through overt manipulations and jarring juxtapositions delivered with a cool detached hand. It was installed with the artist's blessing in a double-height area of Byrne's home so that the work—with its tiny figures marooned at the top of an artificially elongated rock formation—could be made out if one viewed it from a second-story landing. These two pieces join seven others in the museum's collection from every stage of Baldessari's career, giving MOCA an enviable position from which to survey his unquestionable achievements.

Robert Gober's elaborate and controversial 1997 exhibition at MOCA was a culminating event for the artist and the museum. The installation featured a concrete cast of the Virgin Mary run through by a metal culvert pipe, water cascading down wooden stairs behind it into an underground aqueous ecosystem coursing below the floor. One part of the installation, *Untitled* (1997), was purchased by the museum, funded in large part through Byrne's efforts, among those of other MOCA supporters. The ambitious work consists of an unassuming suitcase that reveals a surprising interior featuring a metal grate, below which is a lighted space

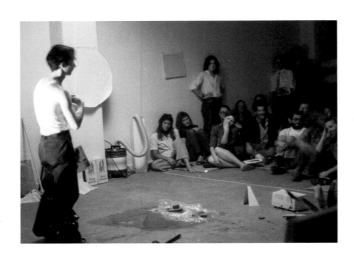 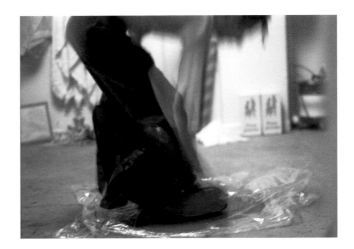

filled with fresh water, plant life, and evidence of human presence. The work has become one of the most beloved in the collection. Three additional works by Gober come to the museum via this most recent gift: the major door sculpture *Untitled* (1998) and two works on paper, *Genital Drawing* (1989) and *Untitled* (1996). The untitled sculpture features two paneled doors in an "X" configuration that is splayed into a corner. Directly related to his similar manipulations of household objects like sinks and cribs, it is exemplary of his particular brand of domestic surrealism. These works join six pieces acquired by the museum since 1992 through gift and purchase that cover many aspects of Gober's career, giving MOCA an extraordinary sampling of the artist's most important themes and motifs.

Mike Kelley has been pivotal to the development of contemporary art both in Los Angeles and internationally, and MOCA has featured him in numerous landmark exhibitions, from "A Forest of Signs: Art in the Crisis of Representation" (1989) to "Helter Skelter: L.A. Art in the 1990s" (1992) and "Out of Actions: Between Performance and the Object, 1949–1979" (1998). The museum has also assembled an unparalleled cross-section of his artistic output, totaling thirty-one paintings, installations, sculptures, and works on paper from 1981 to 1992. The Byrne gift strengthens this already impressive collection by adding key works that both dig deeper into the historical roots of Kelley's career and track more recent developments. The major early work *The Monitor and the Merrimac* (1979), for instance, one of the first pieces Byrne acquired, is a

performance relic that includes two ship sculptures that were used as props worn on the artist's feet. *Silver Ball* (1994), which features among other components a boom box and a looming sphere clad in lumps of cheap aluminum foil, is a multimedia sculptural installation that reveals Kelley's knack for finding a common ground between the mystical and the banal, one of the hallmarks of his practice. Likewise, *Lingam and Yoni (Stony Island)* (2002) is a recent work that presents in a mock-spiritual way the perfect and archaic harmony of male and female forms, a commentary on sexuality and popular culture that has been a notable component of recent bodies of work.

Paul McCarthy has also been an enormously influential figure in the art of the past thirty-plus years, helping to place Los Angeles on the list of global centers for art production. He figured prominently in "Helter Skelter" and was the subject of a solo retrospective exhibition at MOCA in 2000. The Byrne gift includes eight major photographic works that suggest the range of his expressive output and also the sustained relevance of performance to his practice. Throughout the 1970s and 80s, the artist was primarily involved in performance art, using his own body and myriad props and materials to explore issues of sexuality, consumerism, art history, and popular culture. Those activities typically yielded documentary photographs such as the earliest McCarthy work in the gift, *Face Painting/Floor White Line* (1972), as well as related videos, preparatory notes, and drawings. However, in the late 1980s and 90s more permanent sculptural objects and large-scale photographs began to

MIKE KELLEY *The Monitor and the Merrimac*, 1979
Performance at Foundation for Art Resources, Los Angeles, 1979

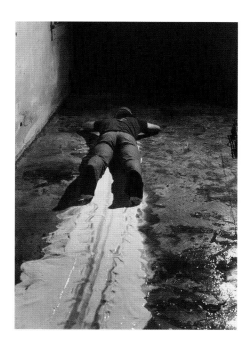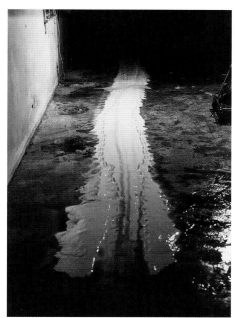

be integrated with his performance-based investigations. The seven color photographs from the Masks series (1994) that are included in the Byrne gift reflect this development. The works are formal portraits of performance props used by the artist, forming a graphic catalogue of his various personas. The mask is an element of McCarthy's work that has been present from his earliest days, seen for the first time in the suite of works on paper *Stoned Blue Drawings* (1968–69) that was recently acquired by the museum. The Byrne photographs, along with these drawings and the multimedia installation by the artist already in the museum's collection, *Tokyo Santa, Santa's Trees* (1999), forms an impressive survey of McCarthy's consistently challenging oeuvre.

The work of the late Spanish sculptor Juan Muñoz was celebrated at the museum in a sprawling 2003 retrospective, which makes Byrne's donation of four Muñoz pieces particularly meaningful. On their own, they represent a survey of the artist's career, ranging in scale from tabletop to environmental and touching on signature themes like architecture and the figure. *Shadow Figure* (2000), for instance, suggests a full-scale metal roll-up door (like one might find on a storefront) in front of which strides a figure whose body is made up of the same ridged materials and dull grey color as the door. *Minarette* (1989), an awkward teetering tower of iron standing adjacent to a Persian-style prayer rug, partakes of a tendency to shift architectural scale which is found throughout his work, while also referencing the Muslim influences of Moorish Spain. *Untitled (Box)* (1988) is related to a well-known series of sculptures the artist made of wooden balustrades, although here two pieces of balustrade molding mysteriously protrude into the interior of a rustic suitcase, achieving a haunting ambiguity that is also a hallmark of his oeuvre. When these pieces are considered in the context of the three

sculptures the museum already owns—one of which, *Untitled (Balcon)* (1984), was previously donated by Byrne—one is once again aware of the amazing depth of perspective the Byrne gift offers on one of the most original artistic voices of our time.

Gabriel Orozco was similarly honored with a large-scale retrospective exhibition at MOCA in 2000, much to Byrne's pleasure. An ardent follower of the Mexican conceptualist's work, he has assembled a sizable collection. Byrne's gift of five of these pieces document the primacy of the artist's works on paper. The gift includes two works that feature handprints—a central motif for Orozco—as well as two pieces, *Untitled (Boarding Pass July 11)* and *Untitled (One Peso Bill)* (both 2001), from a fascinating series in which colorful geometric forms are drawn on or cut out of existing printed matter such as posters, newspaper clippings, money, and transportation tickets. The museum acquired two major works from Orozco's MOCA exhibition, *Toilet Ventilators* (1997/

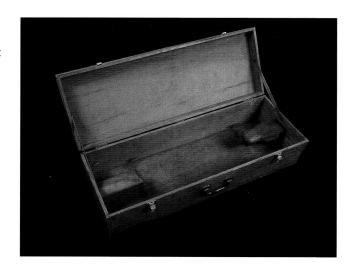

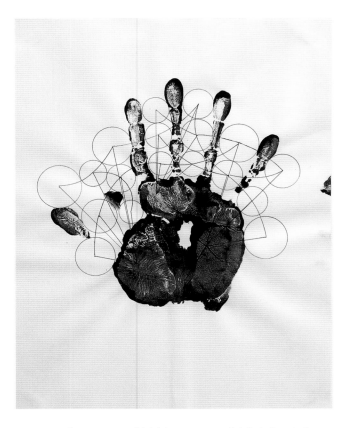

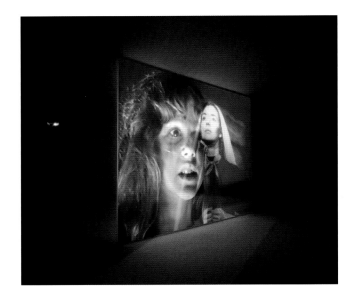

the intersection of two semicircular cuts, as well as a photograph showing the context of the removal. Matta-Clark's simultaneously aggressive, poetic, and banal gesture has resonated with generations of artists and architects, and this piece, one of his last, is one of the most extraordinary in the Byrne gift. The work joins one other piece by the artist, *Splitting* (1974), a dynamic photo-collage that documents a similar action performed on a house in suburban New Jersey.

MOCA organized a major retrospective of Douglas Gordon's work in 2001, after which the museum acquired the video installation *Between Darkness and Light (After William Blake)* (1997). The Byrne gift brings an additional work to the collection, *Monster Reborn* (1996/1997/2002), a photograph of the Scottish artist that, like the video piece, reveals his long-standing interest in the fine line between good and evil, especially as manifested in literature such as Robert Louis Stevenson's *The Strange Case of Dr. Jekyll and Mr. Hyde* (1886).

Steve McQueen was a key figure in the 2001 MOCA group exhibition "Public Offerings," which chronicled the breakthrough early work of artists who helped define contemporary art in the 1990s. As part of the Byrne gift, MOCA proudly receives the artist's work *Drumroll* (1998). In the expansive and enveloping video installation, three camera angles show the artist rolling down a New York City street in an oil drum. Hilarious

2000) and *Ping Pond Table* (1998), which joined three photographs and one work on paper. When viewed together with the other works in the Byrne gift, an ample picture of the artist's methods and preoccupations comes into focus, allowing the museum to represent the artist's work in a much more complete and rich way.

With Byrne's gifts of single pieces by an artist, MOCA's preexisting holdings of the work of Douglas Gordon, Gordon Matta-Clark, Steve McQueen, Ed Ruscha, and Cindy Sherman are also unquestionably enriched, allowing the museum to tell a fuller story of their development. For example, Matta-Clark, who was a prominent figure in the 1999 MOCA exhibition "Afterimage: Drawing Through Process," is represented by a rare sculptural fragment from one of his infamous architectural interventions. *Office Baroque* (1977) is from an action of the same name, during which the artist cut through the floors of a five-story commercial building in Antwerp, Belgium. The work comprises a tear-shaped section of floor and ceiling resulting from

GABRIEL OROZCO *Untitled (Black Hand)*, 2000

DOUGLAS GORDON *Between Darkness and Light (After William Blake)*, 1997, video installation, dimensions variable The Museum of Contemporary Art, Los Angeles. Purchased with funds provided by the Acquisition and Collection Committee

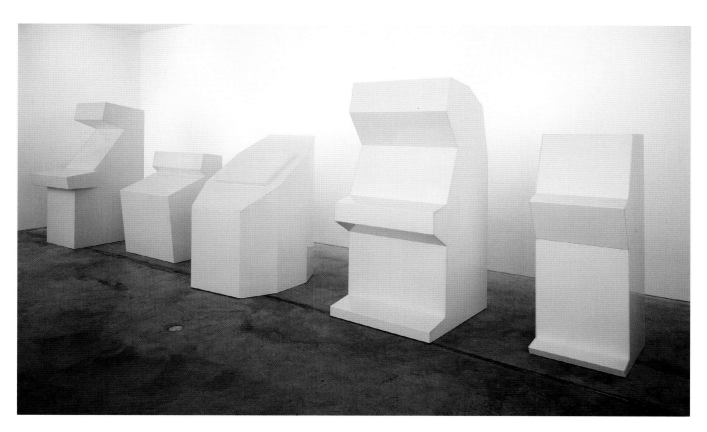

in the manner of Charlie Chaplin or Buster Keaton, aggressive in its imposition on the civic landscape, and horrifying in its claustrophobic disorientation, *Drumroll* is one of the artist's most well-known early works, instrumental in garnering him the Turner Prize in 1999 and representing a milestone in the reemergence of video art in the 1990s. MOCA has pursued signature examples by the leading protagonists in the burgeoning field of video art, including Eija-Liisa Ahtila, Doug Aitken, Douglas Gordon, Rodney Graham, Pipilotti Rist, Catherine Sullivan, and Diana Thater, and McQueen's *Drumroll* is a cornerstone in that recent history.

Ed Ruscha has been honored by not one but two survey exhibitions at MOCA, one in 1990 and a second devoted to his works on paper in 2004. His work is also amply represented in the museum's collection by five paintings, one drawing, one installation, thirteen prints, ten photographs, and sixteen artist's books. One crucial series that has not been represented in the collection, however, is his classic gunpowder drawings of

words floating on grey fields. The Byrne gift fills this gap with the beautiful work *The Briefcase* (1973).

Photography has been another important feature of Byrne's collecting as well as an area to which MOCA has devoted numerous exhibitions—among them, the 1997 retrospective look at Cindy Sherman's influential career. The addition of Sherman's *Untitled* (1999), a disturbing black-and-white image of a dismembered action figure, brings a welcome contemporaneity to the museum's existing holdings of five photographs from 1980 to 1990.

There are several other notable artists whose works in the collection are enriched by the Byrne gift but who have not had major exhibitions at MOCA. The gift complements and strengthens existing holdings of the work of Kai Althoff, Julie Becker, Lynda Benglis, Joseph Cornell, Tony Cragg, Abraham Cruzvillegas, Marlene Dumas, Thomas Eggerer, Mark Grotjahn, Richard Hawkins, Thomas Hirschhorn, Louise Lawler, Rita McBride, Jonathan Pylypchuk, Roman Signer,

RITA McBRIDE *Machines*, 2001, porcelain enamel on steel, dimensions variable
The Museum of Contemporary Art, Los Angeles. Purchased with funds provided by Michael Sandler and Brenda Potter

Luc Tuymans, Christopher Williams, and Paul Winstanley, to name an eclectic few. These works include more historical pieces such as Cornell's *Untitled (Hotel) Box* (1954), which joins MOCA's extensive collection of twenty-five of the artist's assemblages, and Benglis's important *For Bob* (1971), which will represent her process-oriented work from a vantage point different than the museum's *Night Sherbet* (1969) and make a handy comparison with the related *Untitled* (1968). Rita McBride has been a longtime favorite of Byrne, represented by many works in his own collection, and her work *Servants and Slaves (domestic)* (2003) is characteristic of her interest in architecture and its component parts. Leaning toward representation in its suggestion of a shrunken air-conditioning duct, this corner piece also possesses abstract geometric concerns not unrelated to the wall progressions of Donald Judd. MOCA owns one other work by McBride, *Machines* (2001), which reveals a similar predilection for denying specificity to recognizable objects. Holdings of other established artists such as Tony Cragg, Louise Lawler, and Roman Signer are similarly enriched by their respective pieces in the gift *Half Moon* (1985), *This Picture Is the Same Size as the Painting I Was Asked to Photograph* (1999), and *Balloon with Rocket (Ballon mit Rakete)* (1981).

Emerging artists are a particularly strong suit of the Byrne collection, revealing his continued if not increased interest in the latest developments in contemporary art, and his collecting habits have paralleled the museum's in gathering works such as Kai Althoff's *Untitled (Screen)* (2004) and Abraham Cruzvillegas's *El camino secreto* (2003). Althoff's practice is particularly varied; seeing *Untitled (Screen)* together with MOCA's painting *Untitled (Two Men and Woman with Bicycle)* (2001), we can now begin to grasp the complexity of his undertaking. Cruzvillegas too is a prolific and wildly inventive artist; *El camino secreto*, together with MOCA's *Widespread Deformation* (2004), offers a picture of his humorous sculptural universe.

Another long-standing interest of Byrne's has been the work of Marlene Dumas, one of the first artists he began collecting in earnest in 1988. Byrne has developed a close relationship with the artist and has built up a substantial collection of her work, which reveals her unique ability to balance the poetic and the political, fragility and strength, and beauty and horror. The Byrne gift to

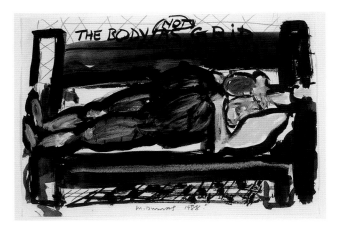

MOCA comprises five works on paper from 1988 to 1992 that, when viewed together with the two large 2001 watercolors already in the collection, highlight her pressing themes of race and sexuality.

Another essential characteristic of the Byrne gift is its representation of works by major international artists who, for one reason or another, have not yet found their way into MOCA's permanent collection. The list includes names such as Georges Adéagbo, Stephan Balkenhol, Guillaume Bijl, Jan Fabre, Christina Iglesias, Yayoi Kusama, Florian Maier-Aichen, Annette Messager, Helmut Newton, Gerhard Richter, Thomas Scheibitz, Beat Streuli, Jan Vercruysse, Jacques Villeglé, and Cosima von Bonin, among others. These artists have all made significant contributions to the development of contemporary art over a period of nearly fifty years, and the opportunity to view their works alongside others already in the MOCA collection will be revelatory.

Byrne's unique perspective as someone who currently splits his time between Los Angeles and Paris gives his collection an unusual range, and many European artists who are not as well known on this coastline are being introduced to MOCA's collection as a result of this perspicacity. German artist Stephan Balkenhol's *Vier Figurengruppe* (1999), like McQueen's *Drumroll*, is too large to have ever been installed in Byrne's home but proved too enticing in its quality to evade his grasp. Balkenhol's signature practice of carving rough-hewn figures from blocks of wood is disarming in its directness and, when combined with the reserved, yet approachable postures of his figures, makes for a deeply humanistic sculptural statement. *Vier Figurengruppe* exemplifies this

MARLENE DUMAS *The Body Not as a Grid*, 1988

characteristic in the artist's work, as four of Balkenhol's "everymen" in white shirts and black pants are arranged in increasing scale on diminishing red pedestals. The shift in scale from figure to figure and only slight alteration of position evokes a range of human confidence and self-possession that one encounters in navigating everyday society. Capturing the gamut from Big Shot to insignificant schlub, the work cuts right to the heart of one of man's chief frailties: the ebb and flow of insecurity. It is exactly this subtle but palpable humanity that connects Balkenhol's work with an important figurative sculptural tradition that is nowhere better illustrated than in one of the museum's other figure groups, Alberto Giacometti's *Tall Figure II* and *Tall Figure III* (both 1960).

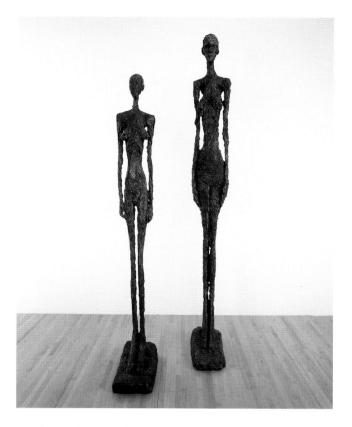

Also reflecting the international nature of the collection but from a more historical vantage point are two pieces by Jacques Villeglé, *Rue Pierre Demours (Léger 1913)* (1958) and *Rue Piroutte* (1962). They not only reflect Byrne's personal connection to Paris but broaden MOCA's representation of postwar abstraction with the museum's first examples of Décollage, a subset of Nouveaux Réalisme. Villeglé was part of a cluster of like-minded artists that also included Mimmo Rotella and Raymond Hains, who found compelling abstract compositions in the layers of colorful posters that accumulated one on top of another on city streets. Whether treated as found artifacts or manipulated with strategic tearing and cropping, the stratified posters made for dynamic allover compositions that both had connections to the equally nonhierarchical compositions of artists like Jackson Pollock and served as counterpoints to the careful collages of earlier artists like Kurt Schwitters or Paul Klee, while also presaging Pop

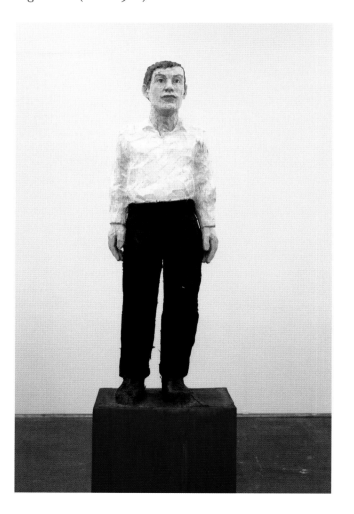

STEPHAN BALKENHOL Detail of *Vier Figurengruppe*, 1999

ALBERTO GIACOMETTI *Tall Figure III* and *Tall Figure II*, both 1960, bronze, 93 x 10¾ x 20½ and 109½ x 10½ x 21¾ inches

The Museum of Contemporary Art, Los Angeles. The Rita and Taft Schreiber Collection. Given in loving memory of her husband, Taft Schreiber, by Rita Schreiber

appropriations of the banal as found in MOCA collection pieces like James Rosenquist's *A Lot to Like* (1962). The rough everyday quality of Villeglé's work and the abrupt juxtapositions it embodies also suggests a meaningful continental kinship with the early work of Robert Rauschenberg, which MOCA proudly owns in depth.

Belgians Guillaume Bijl, Jan Fabre, and Jan Vercruysse round out the international faction of the gift, represented with significant pieces such as Bijl's *Composition trouvée* (1989), a mixed-media installation that takes up issues of exoticism, immigration, and assimilation. It again provides a European viewpoint on a conceptual and formal tradition treated elsewhere in MOCA's collection by artists ranging from Haim Steinbach and Barbara Bloom to Jason Rhoades. The all-encompassing ballpoint-pen surfaces of Fabre's *Saalemander* (1989) meanwhile exhibits the kind of obsessive artistic process that characterizes and energizes existing works in the collection as diverse as those by Ginny Bishton, Russell Crotty, Tom Friedman, or Nancy Rubins. Vercruysse's *Tombeaux* (1989) is an ambiguous object, part painting, part sculpture, part ominous shadow in its dark silhouette of a tomb. The work partakes of a vital tradition of skewing everyday objects, evident in works by American artists in the collection such as Gober, McBride, or Robert Therrien, with which it shares a definite kinship.

The Spanish sculptor Christina Iglesias is also new to MOCA. Her work in the Byrne gift, *Sin título* (1988), is a multimedia wall sculpture that embodies her interests in architecture, history, memory, and materiality. The museum also did not own until this point a work by the well-known French artist Annette Messager. Her tripartite piece *Histoire des robes* (1990) amply communicates her artistic preoccupations with clothing, the body, and memory, while also complementing works in the collection by Messager's husband Christian Boltanski and fellow countrywoman Sophie Calle.

Another welcome benefit of the Byrne gift to MOCA's collection is the addition of works by the important German painter Gerhard Richter, of which only one collaborative work with Sigmar Polke was previously owned. Now, with the addition of *Farbtafel* (1966–78) from Richter's seminal color-chart series, as well as another collaborative work with Polke, *Umwandlung* (1968), the museum can begin to reckon with Richter's towering achievements. His peer and sometime collaborator Polke is also represented in the gift by a solo work, a substantial untitled watercolor from 1982. The work, with its emphatic benday-dot pattern antagonizing the image behind it, reiterates his contributions to the expansion of the terms of Pop art and joins two photoworks from the early 1970s already in the museum's collection.

Several emerging European artists are also introduced to MOCA through the Byrne gift, closely complementing a recent spate of collecting activity by the museum in that area. Two substantial pieces by the wide-ranging German artist Cosima von Bonin, *D'accord* and *Therapy (#62)* (both 2002), show her dexterity in both two and three dimensions. The former is from a recent series of large-scale fabric wall-hangings that form an interesting bridge between crafts and fine art, not dissimilar to the scrambling of categories found in works in MOCA's collection by Los Angeles–based artists Jim Isermann,

JACQUES VILLEGLÉ *Rue Piroutte*, 1962

JAN FABRE *Saalemander*, 1989

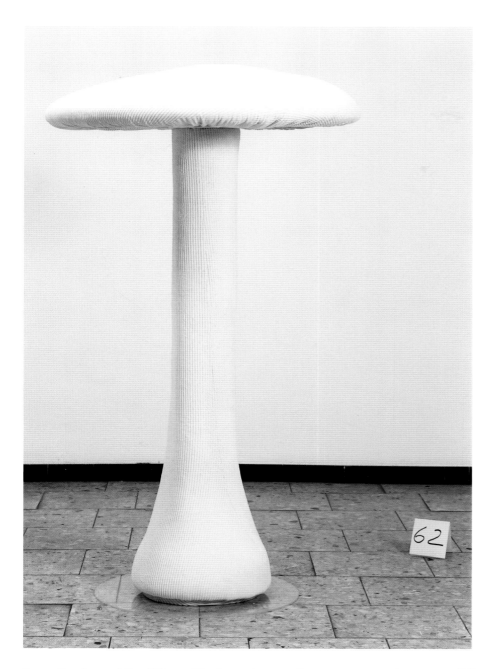

Jorge Pardo, and Pae White. The latter is one of von Bonin's signature mushroom-shaped sculptures that similarly conjure a spectrum of associations. Fellow Germans Thomas Scheibitz and Florian Maier-Aichen are also represented by highly characteristic pieces, Scheibitz by the ambitious abstract painting *Untitled No. 372* (2003) and Maier-Aichen by *Untitled (Factory)* (2001), a mesmerizing color photograph that has been subtly yet unsettlingly manipulated on the computer. The work of Swiss photographer Beat Streuli, who has become well-known for his seemingly casual and often monumental street photographs taken around the world, enters the collection with a work created while visiting Los Angeles, *68/45* (2003).

While it goes without saying that a gift of 123 works by the leading lights of contemporary art is bound to make a great difference to a museum, it is remarkable how complementary Byrne's collecting habits have been to those of MOCA. His support of the museum as an active member of the Board of Trustees naturally gives him a special insight into the personality of MOCA's collection and exhibitions, but that did not guarantee that his personal tastes would dovetail with those of the museum—or vice-versa. Byrne's unique personality is evident in the sensibility coursing through his selections, one that is grounded by a deep reverence for humanity and an appreciation of the poetry of the everyday. The range of his gift also reflects this, and it is perhaps this broad connoisseurship that makes his collection so museum-like and thus so easily assimilated into the spaces it will now call home.

PLATES

GEORGES ADÉAGBO *La vie de Blake*, 1999

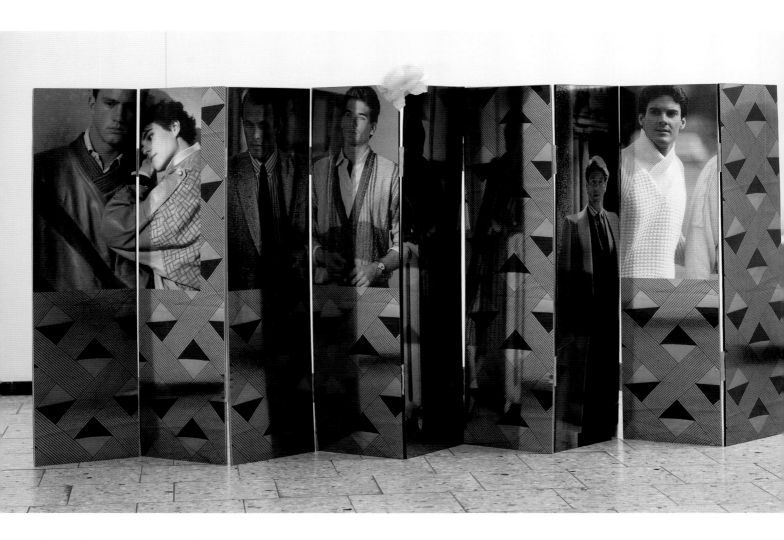

KAI ALTHOFF *Untitled (Screen)*, 2004
opposite **JOHN BALDESSARI** *Mesa*, 1990

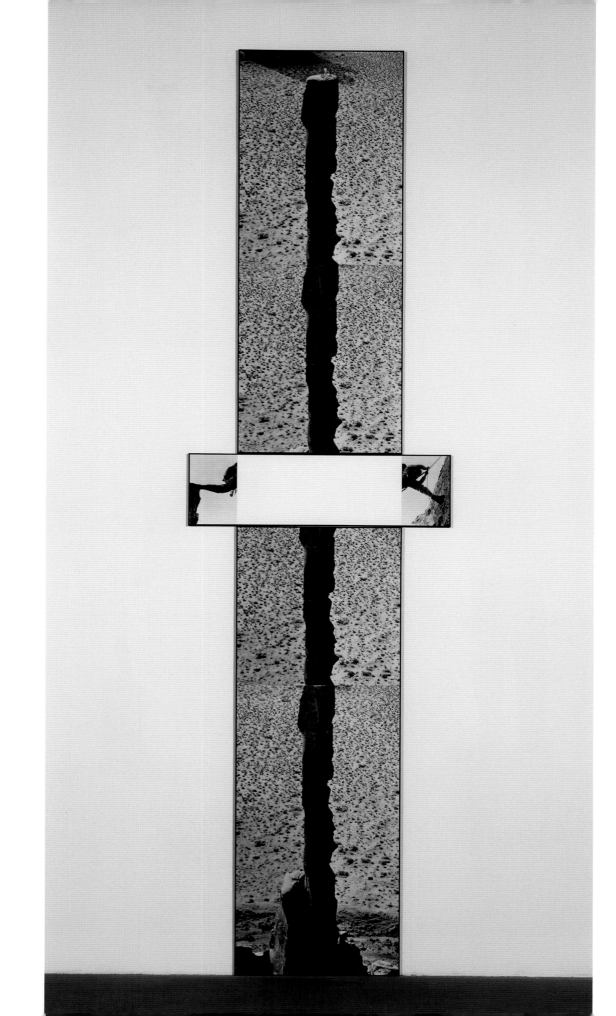

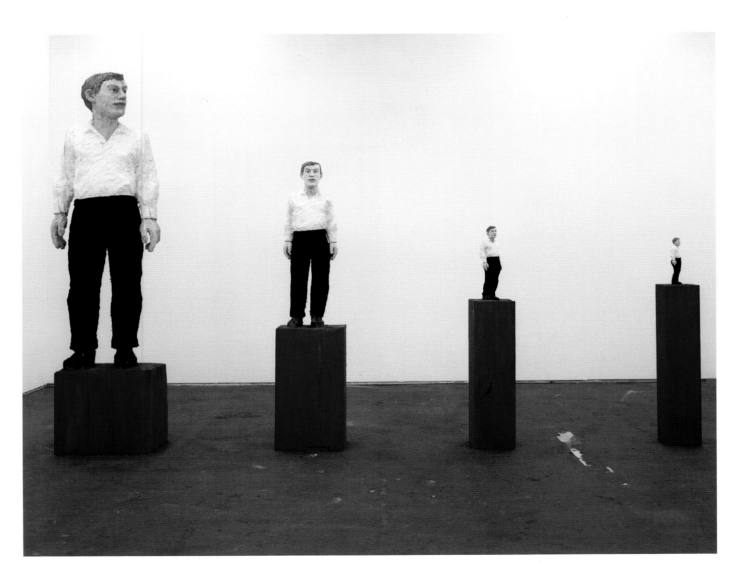

STEPHAN BALKENHOL *Vier Figurengruppe*, 1999

LYNDA BENGLIS *For Bob*, 1971

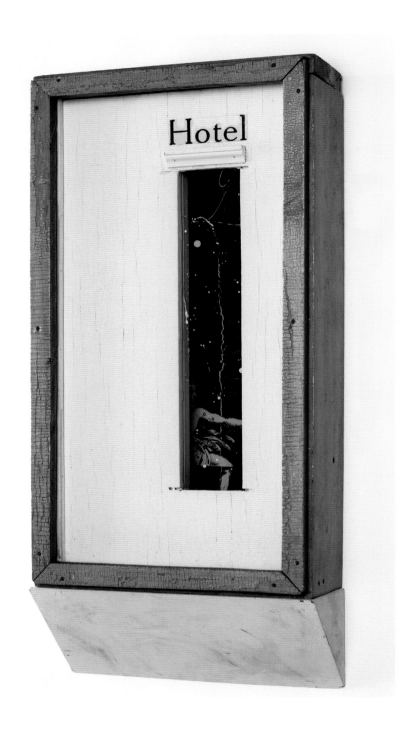

JOSEPH CORNELL *Untitled (Hotel) Box*, 1954

TONY CRAGG *Branchiopods,* 1987

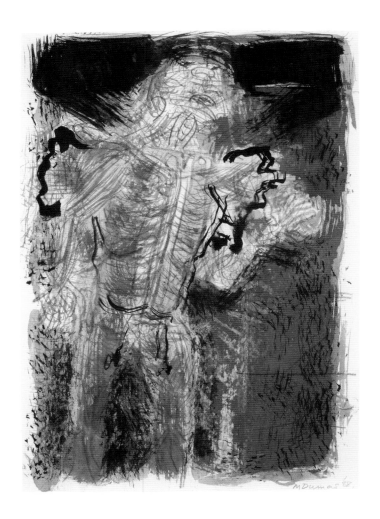 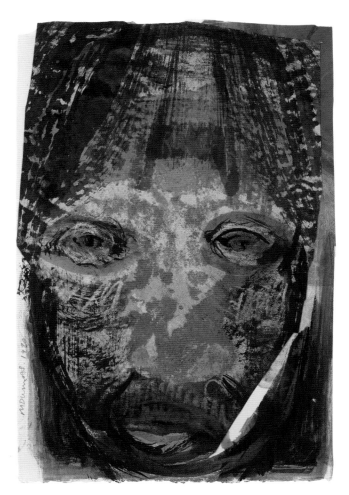

MARLENE DUMAS *Untitled*, 1988, and *Race*, 1990

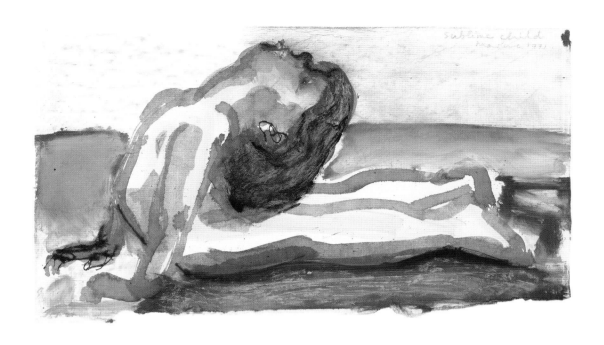

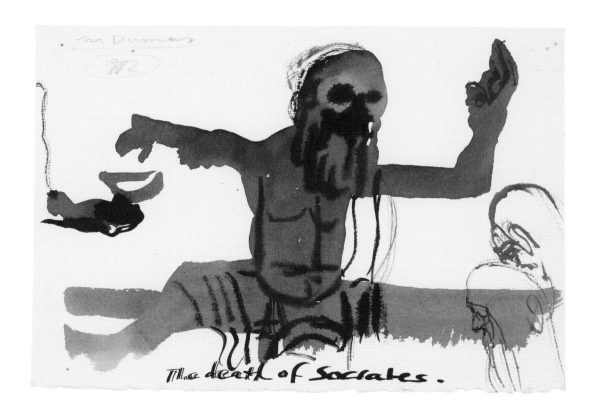

Sublime Child, 1991, and *Death of Socrates*, 1992

THOMAS EGGERER *Drawing for Eugene*, 2003
opposite **ROBERT GOBER** *Untitled*, 1998

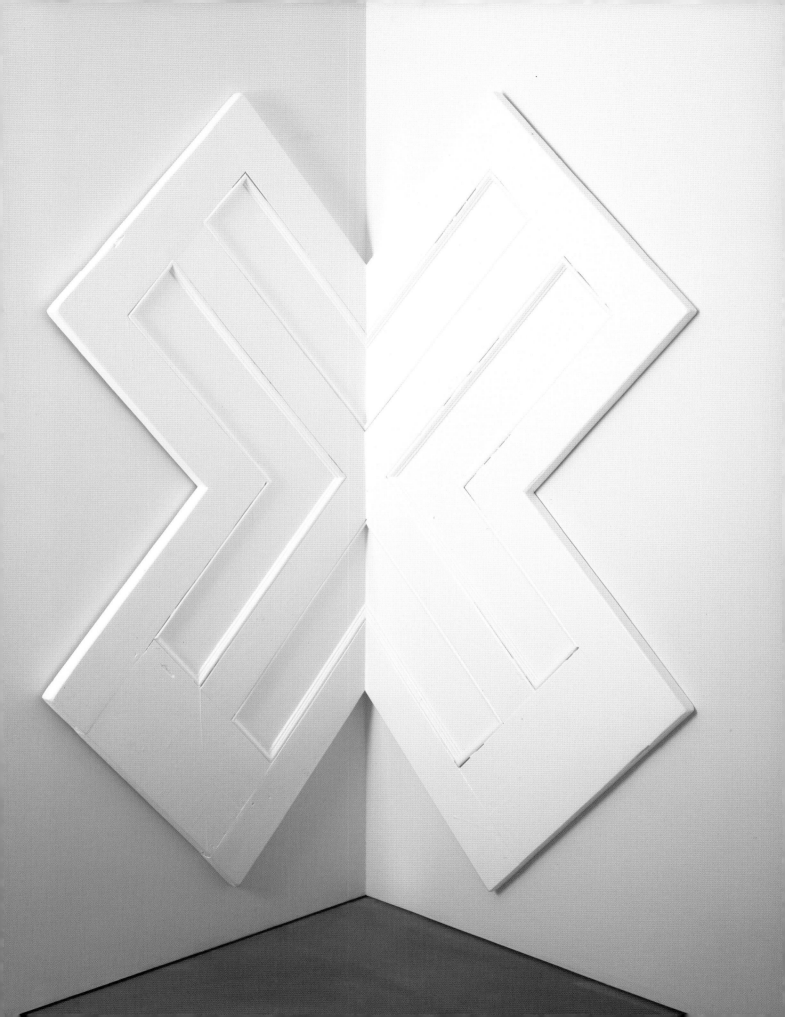

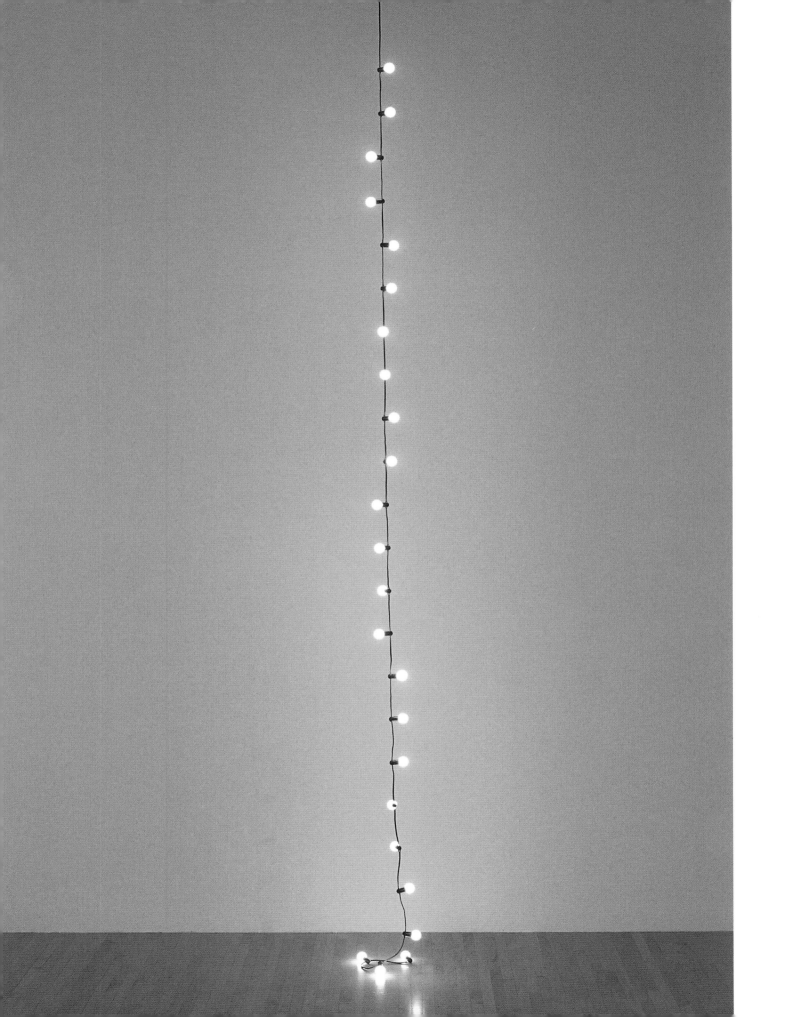

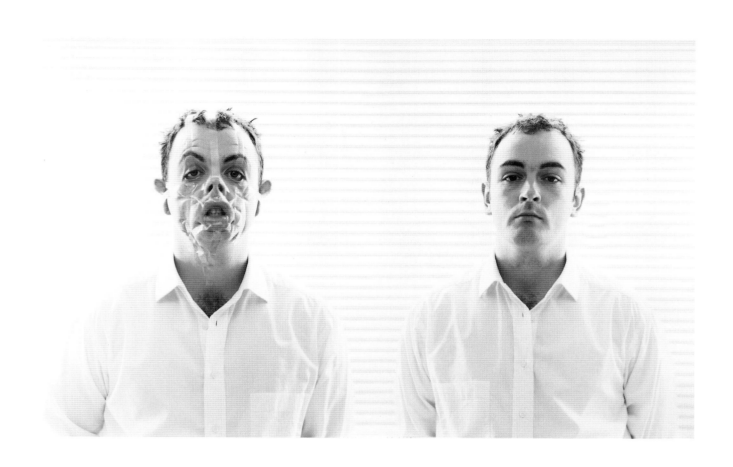

opposite **FELIX GONZALEZ-TORRES** *Untitled (Last Light)*, 1993
DOUGLAS GORDON *Monster Reborn*, 1996/1997/2002

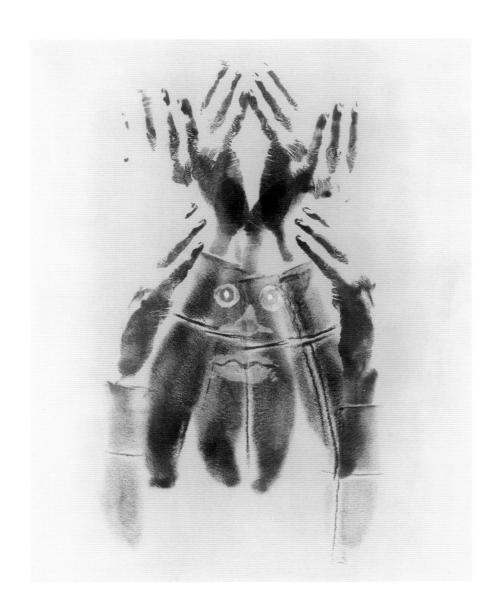

DAVID HAMMONS *Untitled*, 1991

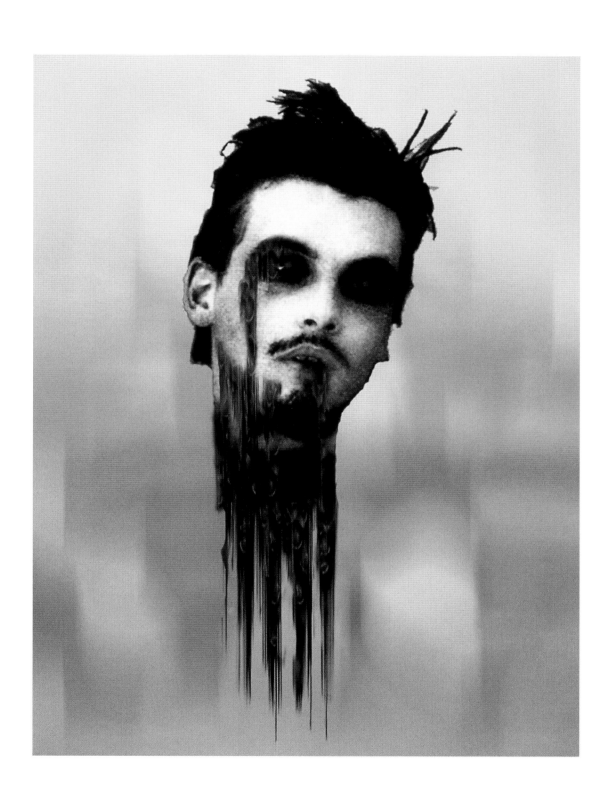

RICHARD HAWKINS *Disembodied Zombie Skeet Pink*, 1997

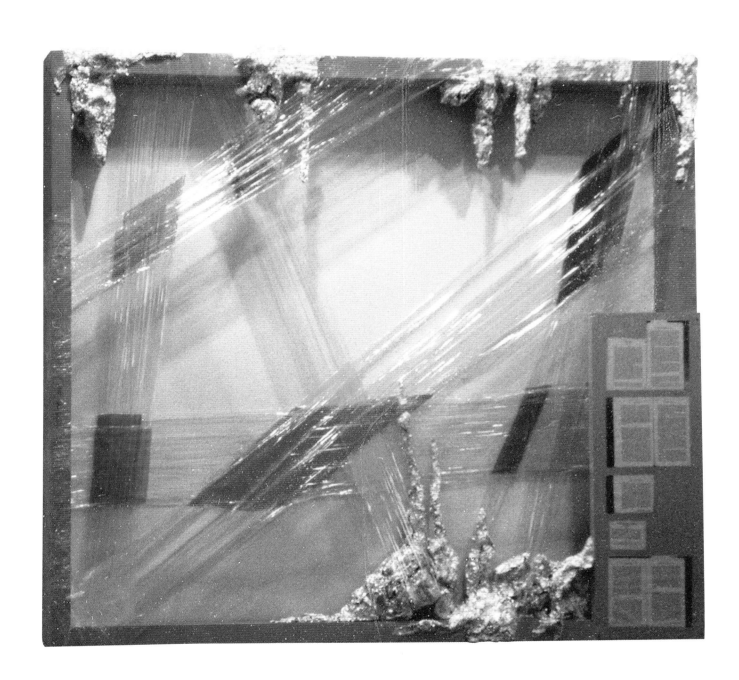

THOMAS HIRSCHHORN *Tableau abstrait*, 1999

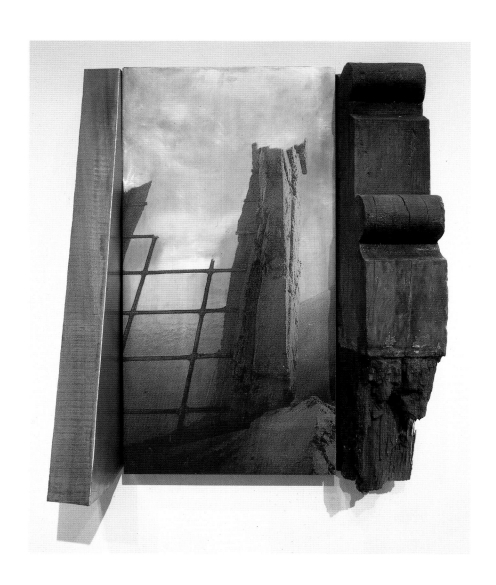

CHRISTINA IGLESIAS *Sin título*, 1988

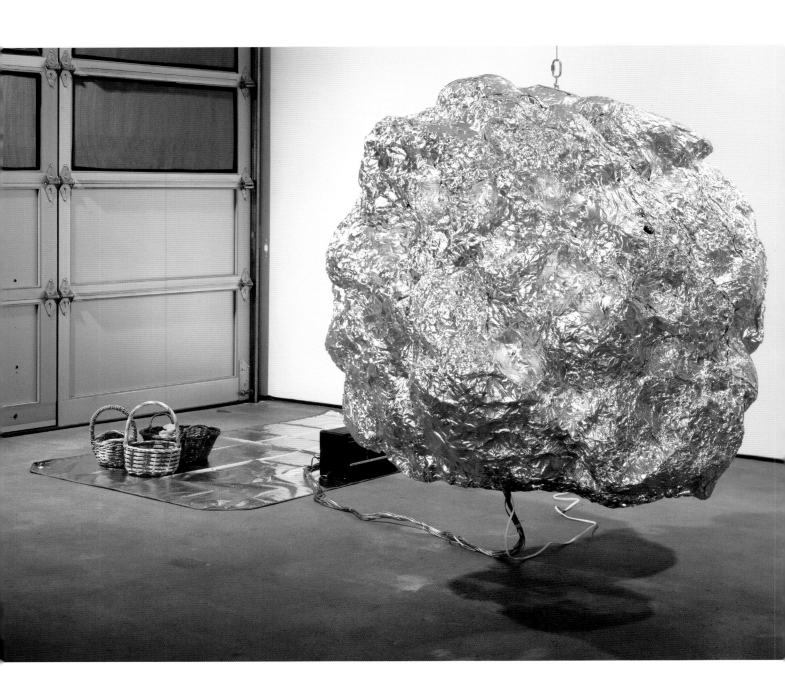

MIKE KELLEY *Silver Ball*, 1994

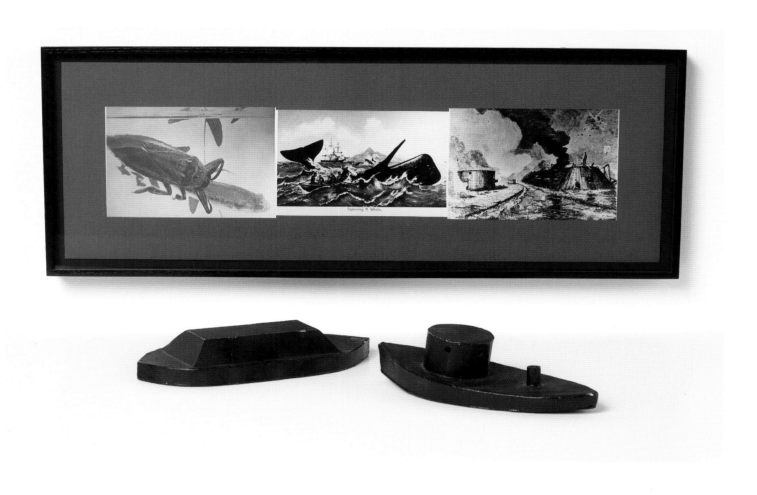

The Monitor and the Merrimac, 1979

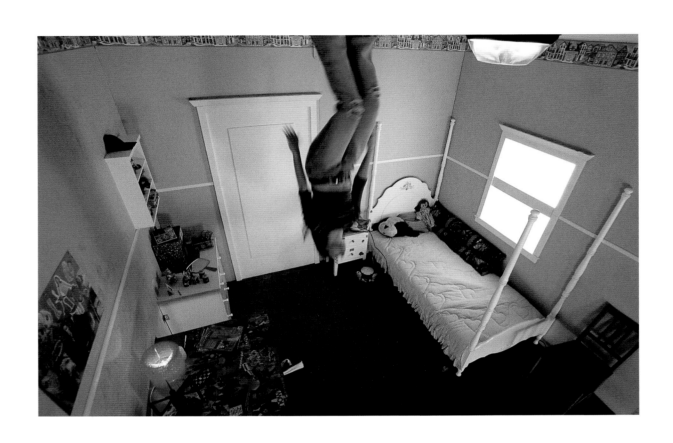

MARTIN KERSELS Still from *Pink Constellation*, 2001
opposite **MARTIN KIPPENBERGER** *New York von der Bronx ausgesehen*, 1985

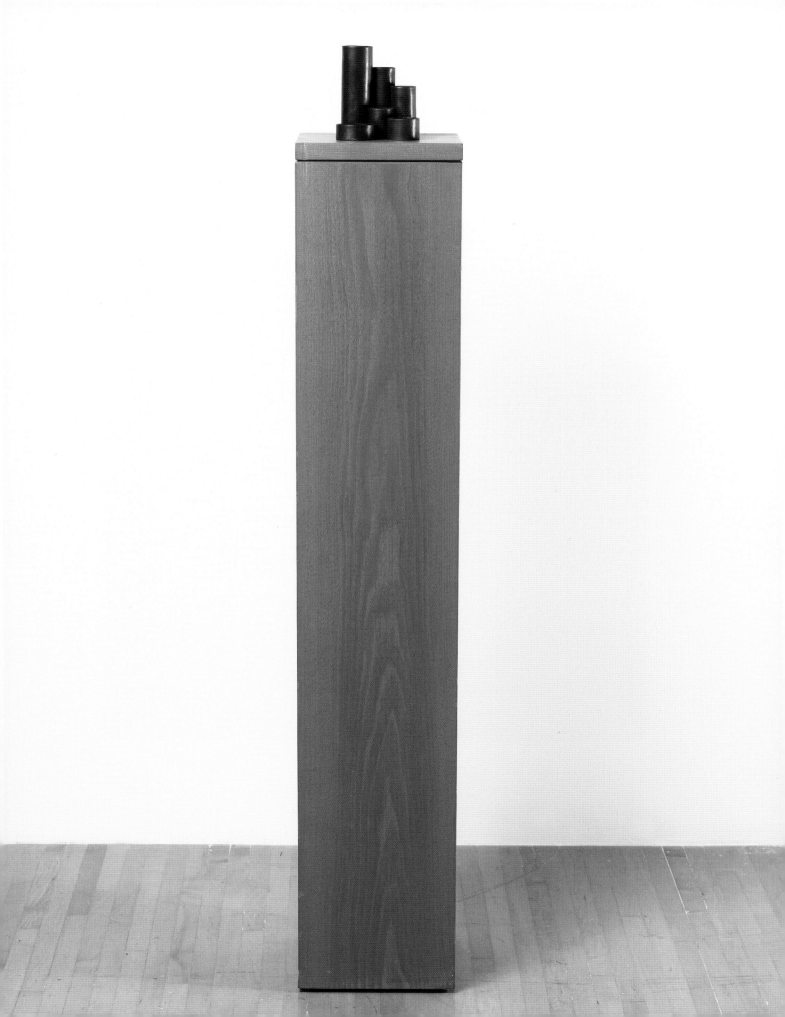

tart (2), n, ME *tarte*, is adopted from MF-F *tarte*, perh orig a var of OF-F *tourte*, from LL *torta* (*panis*), a round (loaf of) bread, a cake, o.o.o. The sl *tart*, a prostitute, is short for *jam tart*, a sweet 'dish'.

JOSEPH KOSUTH *Tart (Art as Idea as Idea)*, 1968

YAYOI KUSAMA *River*, 1991

LOUISE LAWLER *This Picture Is the Same Size as the Painting I Was Asked to Photograph,* 1999

FLORIAN MAIER-AICHEN *Untitled (Factory)*, 2001

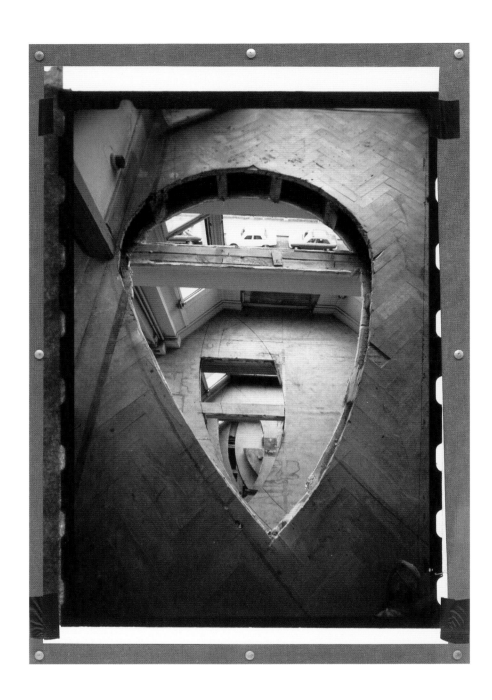

GORDON MATTA-CLARK *Office Baroque*, 1977, and detail of photograph

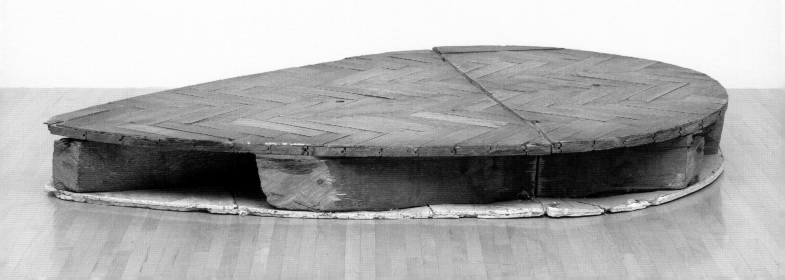

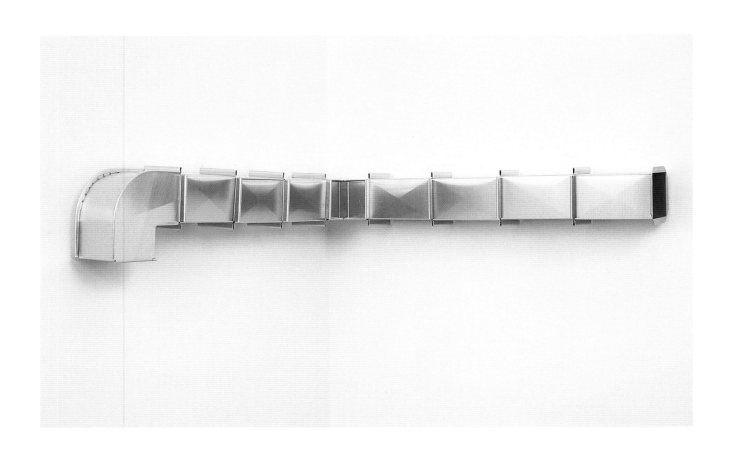

RITA McBRIDE *Servants and Slaves (domestic)*, 2003

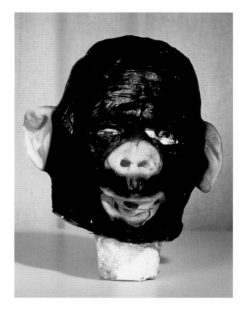

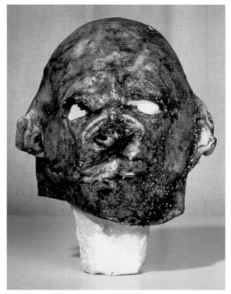

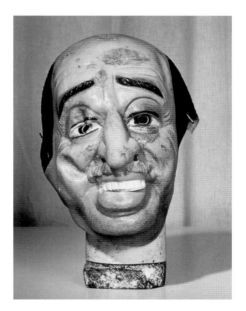

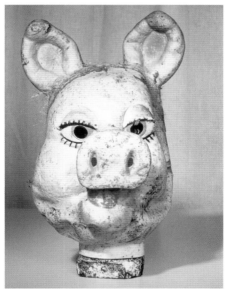

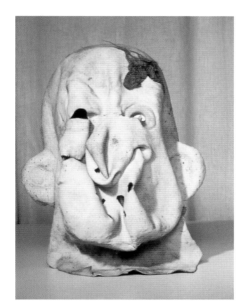

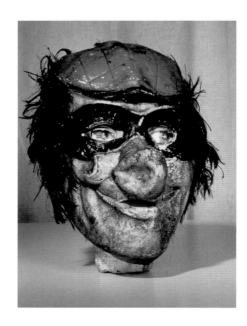

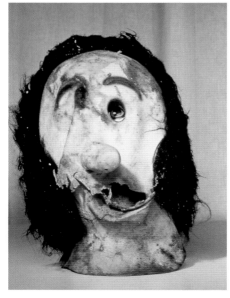

PAUL McCARTHY
Masks (Monkey), 1994
Masks (Monkey Inside Out), 1994
Masks (Arafat), 1994
Masks (Pig), 1994
Masks (Popeye), 1994
Masks (Rocky), 1994
Masks (Olive Oyl), 1994

STEVE McQUEEN Stills from *Drumroll*, 1998

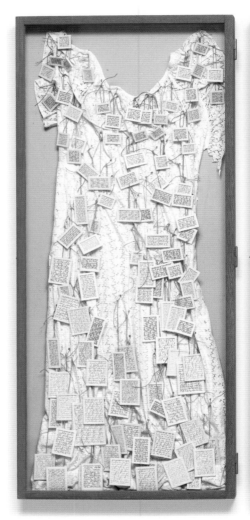
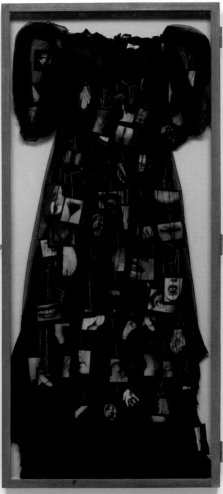
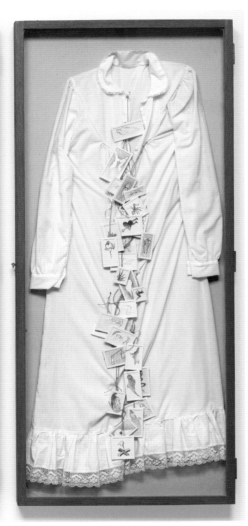

ANNETTE MESSAGER *Histoire des robes*, 1990

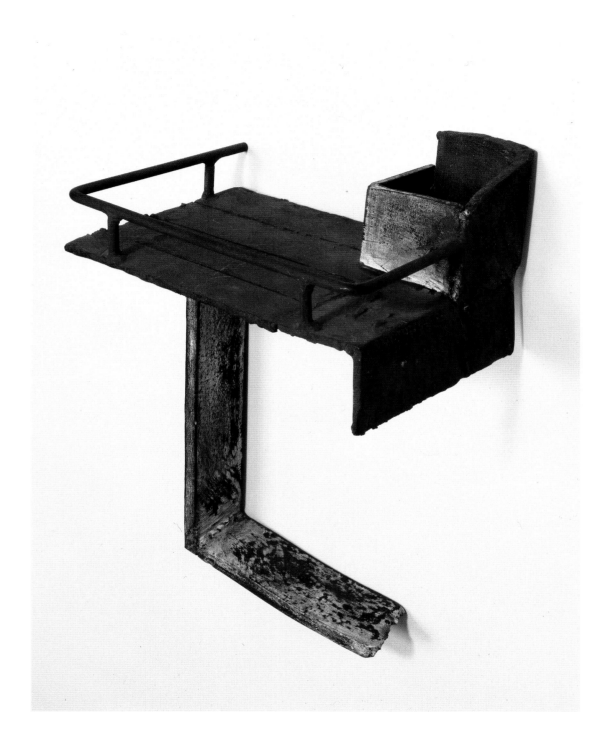

JUAN MUÑOZ *Untitled (Balcon)*, 1984

ALBERT OEHLEN *24-7 Punk*, 2001

CLAES OLDENBURG *Smog Mask*, 1966

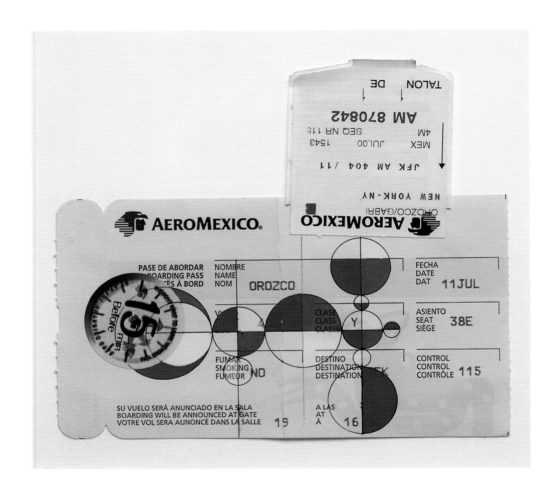

GABRIEL OROZCO *Untitled (Boarding Pass July 11),* 2001

SIGMAR POLKE *Untitled*, 1982

GERHARD RICHTER *Farbtafel*, 1966–78

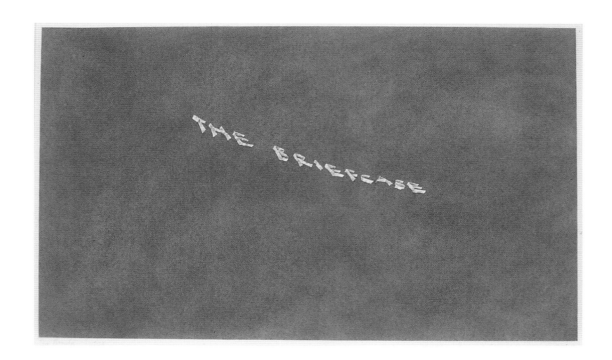

ED RUSCHA *The Briefcase*, 1973

THOMAS SCHEIBITZ *Untitled No. 372*, 2003

JIM SHAW *Untitled (Self-Portrait on the Road to Rochester)*, 1999

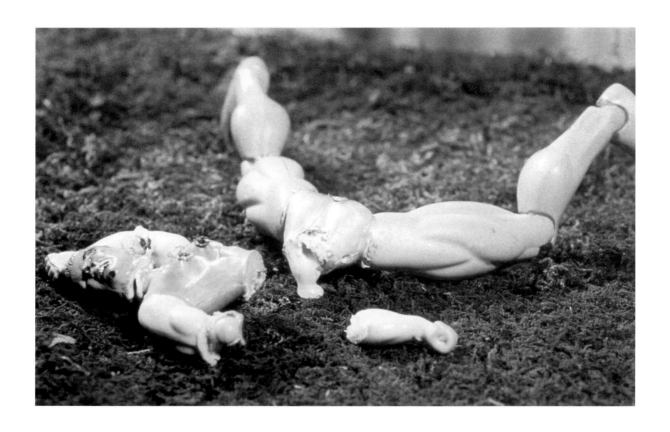

CINDY SHERMAN *Untitled*, 1999

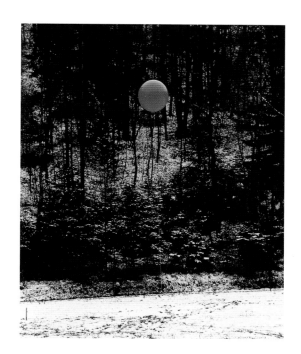

ROMAN SIGNER *Balloon with Rocket (Ballon mit Rakete),* 1981

BEAT STREULI *68/45*, 2003
opposite **RICHARD TUTTLE** *Sand Tree*, 1988

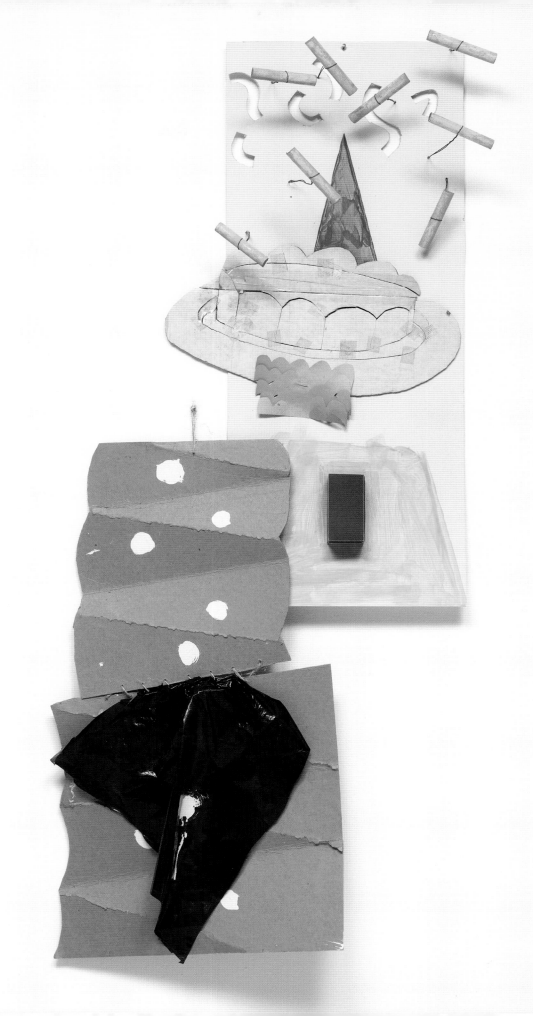

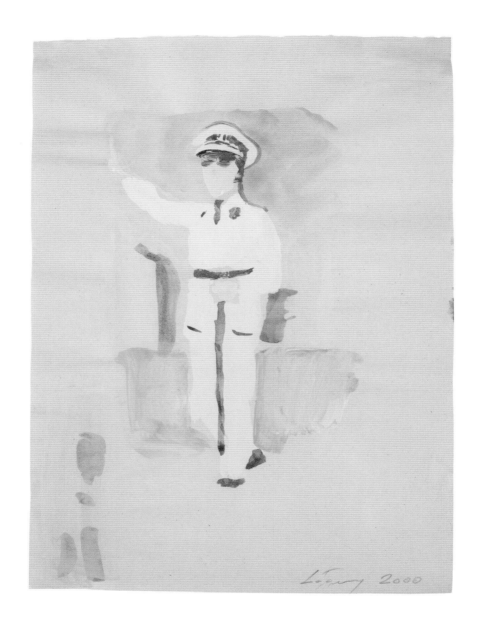

LUC TUYMANS *Boudewijn,* 2000

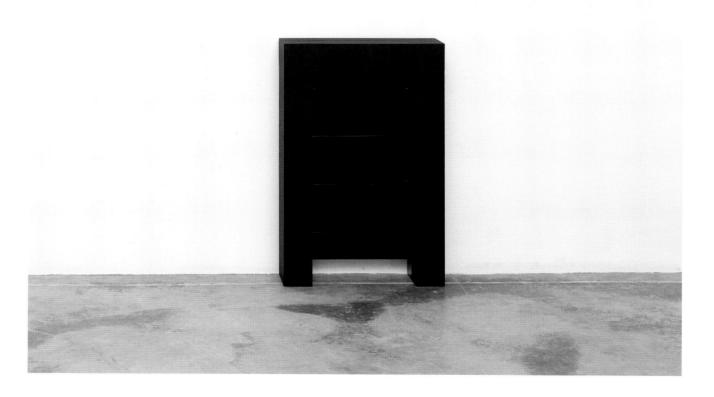

JAN VERCRUYSSE *Tombeaux*, 1989

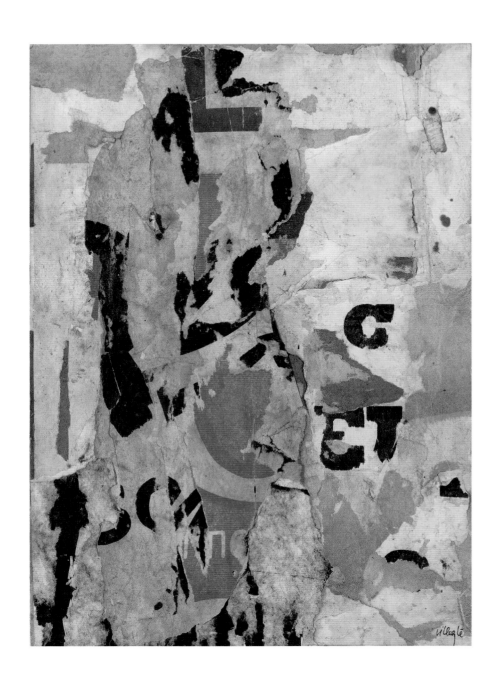

JACQUES VILLEGLÉ *Rue Pierre Demours (Léger 1913)*, 1958

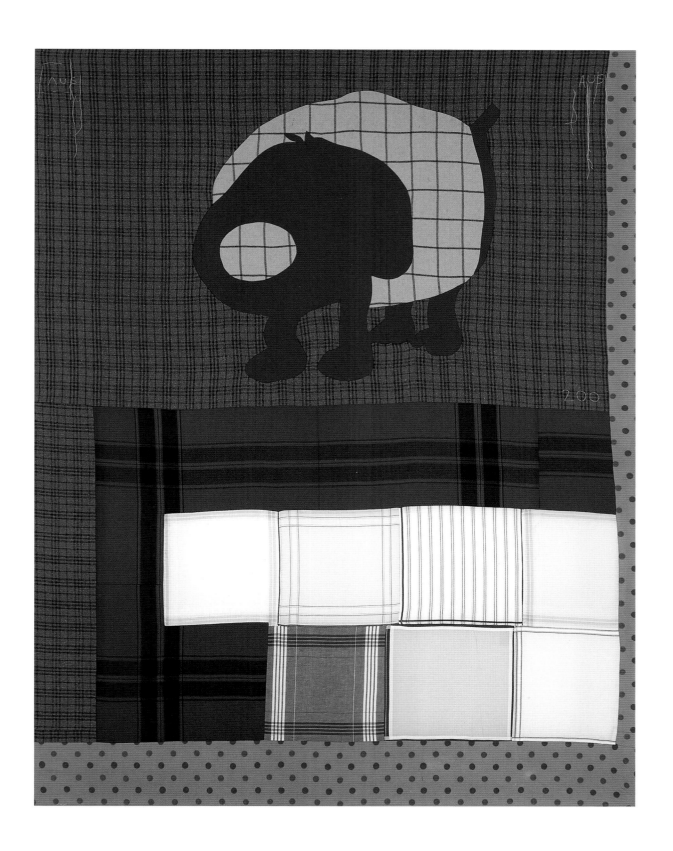

COSIMA von BONIN *D'accord*, 2002

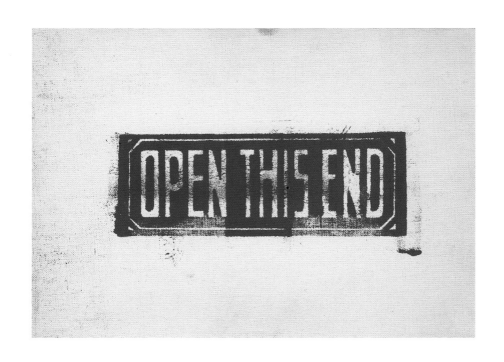

ANDY WARHOL *Open This End*, 1962

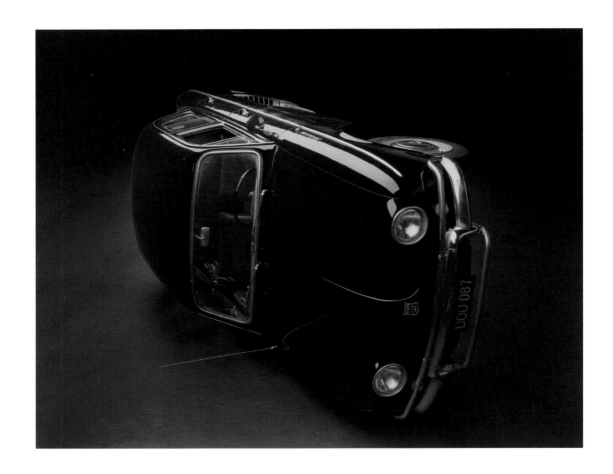

CHRISTOPHER WILLIAMS *Model: 1964 Renault Dauphine-Four, R-1095. Body Type & Seating: 4-dr sedan—4 to 5 persons. Engine Type: 14/52. Weight: 1,397 lbs. Price: $1,495.00 USD (original).*

ENGINE DATA: Base four: inline, overhead-valve four-cylinder. Cast-iron block and aluminum head with removable cylinder sleeves. Displacement: 51.5 cu. in. (845 oc.). Bore and Stroke: 2.28 x 3.15 in. (58 x 80 mm). Compression Ratio: 7.25:1. Brake Horsepower: 32 (SAE) at 4,200 rpm. Torque: 50 lbs. at 2,000 rpm. Three main bearings. Solid valve lifters. Single downdraft carburetor.

CHASSIS DATA: Wheelbase: 89 in. Overall length: 155 in. Height: 57 in. Width: 60 in. Front thread: 49 in. Rear thread: 48 in. Standard Tires: 5.50 x 15.

TECHNICAL: Layout: rear engine, rear drive. Transmission: four-speed manual. Steering: rack and pinion. Suspension (front): independent coil springs. Suspension (back): independent with swing axles and coil springs. Brakes: front/rear disc. Body construction: steel unibody.

PRODUCTION DATA: Sales: 18,432 sold in U.S. in 1964 (all types). Manufacturer: Régie Nationale des Usines Renault, Billancourt, France. Distributor: Renault, Inc., New York, NY, U.S.A.

Serial number: R-10950059799
Engine Number: Type 670-05 #191563
California License Plate number: UOU 087
Vehicle ID Number: 0059799
(For R.R.V.)
Los Angeles, California
January 15, 2000, 2000

MEGAN WILLIAMS *Stirring Up Dust*, 1994

PAUL WINSTANLEY *Veil 6*, 2000

CHECKLIST OF THE BLAKE BYRNE COLLECTION GIFT

Unless otherwise specified, all works are part of the partial and promised gift of Blake Byrne.

GEORGES ADÉAGBO
La vie de Blake, 1999
Mixed-media installation
84 x 84 x 16 inches (213.4 x 213.4 x 40.6 cm)

KAI ALTHOFF
Untitled (Screen), 2004
Velvet, leather, fabric, and photograph on
aluminum on pressboard
49 ¼ x 136 ¾ inches (125.1 x 347.3 cm)

JOHN BALDESSARI
Cigarette Dreams (Raw/Pink/Wit), 1975
Mixed media
22 x 30 inches (55.9 x 76.2 cm)

Mesa, 1990
Mixed media
192 x 52 ½ inches (487.7 x 133.4 cm)

STEPHAN BALKENHOL
Vier Figurengruppe, 1999
Wood
Four figures: 61 ⅞ x 7 ⅞ x 7 ⅞ (156 x 20 x 20);
67 ¹¹⁄₁₆ x 11 ¹³⁄₁₆ x 11 ¹³⁄₁₆ (172 x 30 x 30);
78 ¾ x 19 ¹¹⁄₁₆ x 13 ¾ (200 x 50 x 35); and
110 ¼ x 23 ⅝ x 31 ½ inches (280 x 60 x 80 cm)

JULIE BECKER
Exposed Cave, 1997
Mixed media on paper
14 x 16 ¾ inches (35.6 x 42.5 cm)

LYNDA BENGLIS
For Bob, 1971
Wax on wood and masonite
36 x 5 x 2 ⅞ inches (91.4 x 12.7 x 7.3 cm)

GUILLAUME BIJL
Composition trouvée, 1989
Mixed-media installation
Dimensions variable

JOSEPH CORNELL
Untitled (Hotel) Box, 1954
Mixed media
24 ¾ x 11 ¼ x 4 ½ inches (62.9 x 28.6 x 11.4 cm)

TONY CRAGG
Half Moon, 1985
Mixed-media assemblage
87 x 72 x 2 inches (221 x 182.9 x 5.1 cm)

Branchiopods, 1987
Plaster and wood
32 x 96 x 96 inches
(81.3 x 243.8 x 243.8 cm)
The Museum of Contemporary Art,
Los Angeles
Gift of Blake Byrne, 92.6

ABRAHAM CRUZVILLEGAS
El camino secreto, 2003
Stainless steel and plastic
63 ⅜ x 13 ⅜ x 5 ⅛ inches (161 x 34 x 13 cm)

ROY DOWELL
Untitled, 1995
Acrylic and collage on paper
14 x 10 inches (35.6 x 25.4 cm)

MARLENE DUMAS
The Body Not as a Grid, 1988
Aquarell on paper
8 ¼ x 11 ½ inches (21 x 29.2 cm)

Untitled, 1988
Watercolor on paper
15 ¼ x 12 inches (38.7 x 30.5 cm)

Race, 1990
Collage
12 ½ x 10 inches (31.8 x 25.4 cm)

Sublime Child, 1991
Oil and ink on board
10 ¼ x 7 ¼ inches (26 x 18.4 cm)

Death of Socrates, 1992
Ink on paper
11 ¼ x 14 ¾ inches (28.6 x 37.5 cm)

THOMAS EGGERER
Drawing for Eugene, 2003
Acrylic on paper
29 ⅞ x 27 ½ inches (75.9 x 69.9 cm)

NICOLE EISENMAN
My First Fuck, 1995
Ink and pencil on paper
10 x 15 inches (25.4 x 38.1 cm)

TOSHIKATSU ENDO
Plan for "To Circle", 1991
Mixed media
125 x 95 x 4 ½ inches
(317.5 x 241.3 x 11.4 cm)

KIRSTEN EVERBERG
Blue Jay A., 2003
Enamel and oil on panel
36 x 48 inches (91.4 x 121.9 cm)

JAN FABRE
Saalemander, 1989
Bic ballpoint ink on photograph and
ballpoint ink on plaster
60 x 78 inches (152.4 x 198.1 cm)

TOM FRIEDMAN
Dark room, 1998
Silver-gelatin print, unique
25 ¼ x 19 ¼ inches (64.1 x 48.9 cm)

JOCHEN GERZ
F/T 81—In Eight Parts, 1977
Black-and-white photo/text
Six photographs: 5 x 4 inches (12.7 x 10.2
cm) each; two photographs: 4 x 5 inches
(10.2 x 12.7 cm) each

ROBERT GOBER
Genital Drawing, 1989
Pencil on paper
24 x 16 inches (61 x 40.6 cm)

Untitled, 1996
Acrylic and pencil with tape on copy paper
8 ½ x 11 inches (21.6 x 27.9 cm)

Untitled, 1997
Leather, wood, forged iron, cast plastics,
bronze, silk, satin, steel, wax, human hair,
brick, fiberglass, urethane, paint, lead, motors,
and water, edition 1/2
122 ½ x 104 x 75 inches
(311.2 x 264.2 x 190.5 cm);
above ground: 35 ½ x 35 ½ x 40 inches
(90.2 x 90.2 x 101.6 cm)
The Museum of Contemporary Art,
Los Angeles. Purchased with funds provided
by E. Blake Byrne, Sharon R. Menendez and
Eugenio Lopez, and The Buehler Family
Foundation, 99.18

Untitled, 1998
Wood, steel, and enamel
81⅝ x 58 x 41⅜ inches
(207.3 x 147.3 x 105.1 cm)

FELIX GONZALEZ-TORRES
Untitled (Last Light), 1993
Ten-watt light bulbs, plastic light sockets,
extension cord, and dimmer switch,
edition 6/24
Dimensions variable

DOUGLAS GORDON
Monster Reborn, 1996/1997/2002
Color photograph, edition 5/11
32 ¾ x 48 ¾ inches (83.2 x 123.8 cm)

MARK GROTJAHN
Untitled (White Butterfly), 2003
Prismacolor pencil on paper
23 x 18 inches (58.4 x 45.7 cm)

DAVID HAMMONS
Untitled, 1991
Gouache on paper
24 x 18 inches (61 x 45.7 cm)

RICHARD HAWKINS
Disembodied Zombie Skeet Pink, 1997
Inkjet print, edition 2/3
47 x 36 inches (119.4 x 91.4 cm)

BRUCE HELANDER
Angel's Ajar, 1994
Collage on paper
16 ½ x 12 ¼ inches (41.9 x 31.1 cm)

Shoe Steps, 1997
Paper collage on board
21 x 15 1/4 inches (53.3 x 38.7 cm)

THOMAS HIRSCHHORN
Tableau abstrait, 1999
Wood, aluminum foil, plastic wrap, and paper
70⅞ x 86⅝ inches (180 x 220 cm)

SALOMON HUERTA
Untitled Head #16, 2002
Oil on canvas on panel
12 x 11 ¾ inches (30.5 x 29.8 cm)

FABRICE HYBERT
Angel, 1999–2002
Mixed media on canvas
57 ½ x 44 ¾ inches (146.1 x 113.7 cm)

CHRISTINA IGLESIAS
Sin título, 1988
Wood and photographic transfer on copper
28 x 21 ½ x 8 ¾ inches (71.1 x 54.6 x 22.2 cm)

MIKE KELLEY
The Monitor and the Merrimac, 1979
Acrylic on cardboard and three photocopies
4 x 21 x 38 inches (10.2 x 53.3 x 96.5 cm)

Silver Ball, 1994
Aluminum foil, polyurethane foam, wood,
chicken wire, speakers, four boom boxes,
three baskets, and artificial fruit
Ball: 57⅞ x 57⅞ x 53⅛ inches
(147 x 147 x 135 cm); blanket area:
13 x 46⅞ x 81⅞ inches (33 x 119 x 208 cm)

Lingam and Yoni (Stony Island), 2002
Dirt, found objects, metal, resin, cloth,
acrylic medium, epoxy, fiberboard cylinder,
and wood veneer
54 ½ x 24 x 24 inches (138.4 x 61 x 61 cm)

MARTIN KERSELS
Pink Constellation, 2001
DVD, edition 8/10
Dimensions variable

MARTIN KIPPENBERGER
Form und Farbe, 1982
Mixed media on canvas
23⅝ x 19 ¹¹⁄₁₆ inches (60 x 50 cm)

New York von der Bronx ausgesehen, 1985
Bronze, edition 1/3
60 ¾ x 9⅞ x 9⅞ inches
(154.3 x 25.1 x 25.1 cm)

Tic Tac Toe, Tae Kwon Do, 1990
Mixed-media assemblage, edition 13/30
Nine frames: 12 x 12 inches (30.5 x 30.5 cm)
each

Untitled, 1992
Mixed-media collage on board
8⅞ x 25 ¾ inches (22.5 x 65.4 cm)

JOSEPH KOSUTH
Tart (Art as Idea as Idea), 1968
Photostat on paper mounted on board
36 x 36 inches (91.4 x 91.4 cm)

YAYOI KUSAMA
River, 1991
Acrylic on canvas
28 ¾ x 24 inches (73 x 61 cm)

Sprout, 1993
Acrylic and mixed media on wood
18 ¼ x 13 x 5 inches (46.4 x 33 x 12.7 cm)

TOM LaDUKE
Import, 2001
Military enamel, watercolor, aluminum paint,
and Sculpey III on aluminum
18 ¼ x 20 inches (46.4 x 50.8 cm)

LOUISE LAWLER
*This Picture Is the Same Size as the Painting
I Was Asked to Photograph*, 1999
Cibachrome print, edition 4/5
20⅝ x 15 ¹⁄₁₆ inches (52.4 x 38.3 cm)

RICHARD LONG
Untitled, 1988
River Avon mud on paper
16⅛ x 12 ¼ inches (41 x 31.1 cm)

FLORIAN MAIER-AICHEN
Untitled (Factory), 2001
C-print, edition 4/6
50 ¾ x 65⅛ inches (128.9 x 165.4 cm)

GORDON MATTA-CLARK
Office Baroque, 1977
Parquet wood flooring, drywall, and wood with
Cibachrome print on masonite
Photograph: 30 x 20 inches (76.2 x 50.8 cm);
floor: 15 ¾ x 59 x 90 ½ inches
(40 x 149.9 x 229.9 cm)

RITA McBRIDE
Servants and Slaves (domestic), 2003
Nickel, silver, and aluminum
7 ¾ x 24 x 5 ½ inches (19.7 x 61 x 14 cm)

PAUL McCARTHY
Face Painting/Floor White Line, 1972
Black-and-white photographs
Two photographs: 23 ¼ x 17 ¼ inches
(59.1 x 43.8 cm) each

Masks (Arafat), 1994
Cibachrome print, edition 2/3
72 x 48 inches (182.9 x 121.9 cm)

Masks (Monkey), 1994
Cibachrome print, edition 2/3
72 x 48 inches (182.9 x 121.9 cm)

Masks (Monkey Inside Out), 1994
Cibachrome print, edition 2/3
72 x 48 inches (182.9 x 121.9 cm)

Masks (Olive Oyl), 1994
Cibachrome print, edition 2/3
72 x 48 inches (182.9 x 121.9 cm)

Masks (Pig), 1994
Cibachrome print, edition 2/3
72 x 48 inches (182.9 x 121.9 cm)

Masks (Popeye), 1994
Cibachrome print, edition 2/3
72 x 48 inches (182.9 x 121.9 cm)

Masks (Rocky), 1994
Cibachrome print, edition 2/3
72 x 48 inches (182.9 x 121.9 cm)

STEVE McQUEEN
Drumroll, 1998
Triptych, color video projection with sound
Dimensions variable

ANNETTE MESSAGER
Histoire des robes, 1990
Mixed media
57 x 78 inches (144.8 x 198.1 cm)

TATSUO MIYAJIMA
Counter Spiral No. 4, 1998
Mixed media
40 ⅛ x 15 ¾ inches (101.9 x 40 cm)

DONALD MOFFETT
Lot 052499, 1999
Oil on linen
16 ½ x 12 inches (41.9 x 30.5 cm)

MATT MULLICAN
2 City Plans, 1988
Pencil on paper
40 ¾ x 52 ¾ inches (103.5 x 134 cm)

JUAN MUÑOZ
Untitled (Balcon), 1984
Iron
14 x 9 x 6 inches (35.6 x 22.9 x 15.2 cm)
The Museum of Contemporary Art,
Los Angeles. Gift of Blake Byrne in memory
of the artist, 2002.9

Untitled (Vessel), 1985
Bronze
26 x 20 x 24 inches (66 x 50.8 x 61 cm)

Untitled (Box), 1988
Wood
8 ½ x 36 x 13 inches (21.6 x 91.4 x 33 cm)

Minarette, 1989
Iron and carpet
68 x 21 ½ x 20 inches (172.7 x 54.6 x 50.8 cm)

Shadow Figure, 2000
Polyester resin
98 ½ x 50 ½ x 17 ¼ inches
(250.2 x 128.3 x 43.8 cm)

HELMUT NEWTON
Patricia Faure, 1965
Silver gelatin print
24 x 20 inches (61 x 50.8 cm)

ALBERT OEHLEN
24-7 Punk, 2001
Inkjet and oil on canvas
59 x 43 ¼ inches (149.9 x 109.9 cm)

Untitled, 1994
Mixed media on paper
20 x 28 inches (50.8 x 71.1 cm)

CLAES OLDENBURG
Chocolates, 1966
Enamel over Cadbury English chocolates,
plastic, and cardboard
6 x 12 inches (15.2 x 30.5 cm)

Smog Mask, 1966
Mixed media on paper
15 x 12 inches (38.1 x 30.5 cm)

Hanging Three-Way Plug, 1973
Pastel on paper
13 ⅜ x 11 inches (34.6 x 27.9 cm)

GABRIEL OROZCO
Untitled, 1992
Graphite, toothpaste spit,
and coffee stains on paper
6 ¼ x 6 ¾ inches (15.9 x 17.1 cm)

Untitled (Black Hand), 2000
Pencil and ink on paper
11 ¾ x 9 inches (29.8 x 22.9 cm)

Fear Not, 2001
Drawing, collage, acrylic, and wood discs
12 ½ x 9 ⅜ inches (31.8 x 23.8 cm)

Untitled (Boarding Pass July 11), 2001
Gouache on paper boarding pass
3 ⅜ x 7 ½ inches (8.6 x 19.1 cm)

Untitled (One Peso Bill), 2001
Pencil and gouache on one-peso bill
2 ¾ x 6 ⅛ inches (7 x 15.6 cm)

SIGMAR POLKE and GERHARD RICHTER
Umwandlung, 1968
Lithograph, edition 189/200
19 ⅝ x 27 ½ inches (49.8 x 69.9 cm)

SIGMAR POLKE
Untitled, 1982
Watercolor on paper
27 ½ x 39 inches (69.9 x 99.1 cm)

JONATHAN PYLYPCHUK
Your Forgiveness Is Paramount, 2000
Mixed media on panel
27 ½ x 25 ⅝ inches (69.9 x 65.1 cm)

GERHARD RICHTER
Farbtafel, 1966–78
Lacquer on canvas
27 ½ x 25 ⅝ inches (69.9 x 65.1 cm)

EDWARD RUSCHA
The Briefcase, 1973
Gunpowder on paper
13 x 21 ½ inches (33 x 54.6 cm)

THOMAS SCHEIBITZ
Untitled No. 372, 2003
Oil on linen
57 ⅛ x 98 ½ inches (145.1 x 250.2 cm)

JIM SHAW
Untitled Face Drawing #26, 1984
Pencil and airbrush on paper
15 x 11 ½ inches (38.1 x 29.2 cm)

Surinam Toad Advent Calendar, 1990
Styrene with acrylic, watercolor, and ink
16 x 10 x 2 inches (40.6 x 25.4 x 5.1 cm)

Untitled (Vietnamese Shooting), 1992
Pencil on rag paper
17 ¼ x 14 ¼ inches (43.8 x 36.2 cm)

Untitled (Self-Portrait on the Road to Rochester), 1999
Gouache on board
9 ¾ x 6 ¼ inches (24.8 x 15.9 cm)

CINDY SHERMAN
Untitled, 1999
Black-and-white photograph, edition 3/10
25 ½ x 38 ½ inches (64.8 x 97.8 cm)

ROMAN SIGNER
Balloon with Rocket (Ballon mit Rakete), 1981
C-prints, edition of 10, artist's proof 1/3
Two photographs: 13 ¾ x 10 inches
(34.9 x 25.4 cm) each

NANCY SPERO
Untitled, 1988
Painting and collage on paper
24 x 19 ½ inches (61 x 49.5 cm)

GEORGINA STARR
Hypnodreamdruff (Dream Interference),
1996
Mounted color photograph, edition 8/10
48 x 72 inches (121.9 x 182.9 cm)

Hypnodreamdruff (Frenchy), 1996
Mounted color photograph, edition 8/10
48 x 72 inches (121.9 x 182.9 cm)

Hypnodreamdruff (Hungry Brain), 1996
Mounted color photograph, edition 8/10
48 x 72 inches (121.9 x 182.9 cm)

Hypnodreamdruff (Magic), 1996
Mounted color photograph, edition 8/10
48 x 72 inches (121.9 x 182.9 cm)

GEORGE STOLL
Untitled #2 (Tupperware), 1996
Beeswax and paraffin with pigment
10 x 6 x 6 inches (25.4 x 15.2 x 15.2 cm)

BEAT STREULI
68/45, 2003
C-print, edition 1/3
59 1/16 x 78 3/4 inches (150 x 200 cm)

SPENCER SWEENEY
My Guy, 2002
Mixed media on paper
10 1/2 x 8 inches (26.7 x 20.3 cm)

Untitled, 2003
Mixed media on paper
11 7/8 x 9 inches (30.2 x 22.9 cm)

ANDRE THOMPKINS
Untitled, 1967
Pencil and watercolor on paper
7 1/4 x 9 7/8 inches (18.4 x 25.1 cm)

RICHARD TUTTLE
IV 33, 1977
Watercolor and collage on paper
14 x 10 3/4 inches (35.6 x 27.3 cm)

Sand Tree, 1988
Paper, cardboard, plastic, collage, and wire
60 1/4 x 36 x 8 inches (153 x 91.4 x 20.3 cm)

LUC TUYMANS
Study for Home Sweet Home, 1996
Oil on paper
4 x 6 inches (10.2 x 15.2 cm)

Boudewijn, 2000
Watercolor on paper
29 x 21 inches (73.7 x 53.3 cm)

TAM VAN TRAN
Untitled, 1999
Ink, white-out, collage, aluminum, and staples
on paper
14 x 11 inches (35.6 x 27.9 cm)

JAN VERCRUYSSE
Tombeaux, 1989
Wood, pigment, lacquer, and paint
27 1/2 x 17 3/4 x 4 5/16 inches (69.9 x 45.1 x 11 cm)

JACQUES VILLEGLÉ
Rue Pierre Demours (Léger 1913), 1958
Torn posters pasted on cardboard
11 3/4 x 8 1/4 inches (29.8 x 21 cm)

Rue Piroutte, 1962
Torn posters pasted on plywood
14 1/8 x 20 5/8 inches (35.9 x 52.4 cm)

COSIMA von BONIN
D'accord, 2002
Wool and cotton
102 3/8 x 78 3/4 inches (260 x 200 cm)

Therapy (#62), 2002
Perspex, timber, cloth, and foam
52 x 31 1/8 x 31 1/8 inches
(132.1 x 79.1 x 79.1 cm)

ANDY WARHOL
Open This End, 1962
Acrylic on canvas
8 x 11 inches (20.3 x 27.9 cm)

Self-Portrait (Fright Wig), 1986
Color Polaroid
12 1/4 x 11 inches (31.1 x 27.9 cm)

Self-Portrait in Fright Wig, 1986
Color Polaroid
14 x 12 inches (35.6 x 30.5 cm)

JOHN WATERS
Self-Portrait #3, 2003
Chromogenic color prints
16 1/2 x 70 1/2 inches (41.9 x 179.1 cm)

T. J. WILCOX
By Night I'm One Hell of a Lover, 2001
C-print
8 x 18 inches (20.3 x 45.7 cm)

CHRISTOPHER WILLIAMS
Model: 1964 Renault Dauphine-Four, R-
1095. Body Type & Seating: 4-dr sedan—
4 to 5 persons. Engine Type: 14/52. Weight:
1,397 lbs. Price: $1,495.00 USD (original).

ENGINE DATA: Base four: inline, overhead-
valve four-cylinder. Cast-iron block and
aluminum head with removable cylinder
sleeves. Displacement: 51.5 cu. in. (845 oc.).
Bore and Stroke: 2.28 x 3.15 in.
(58 x 80 mm). Compression Ratio: 7.25:1.
Brake Horsepower: 32 (SAE) at 4,200 rpm.
Torque: 50 lbs. at 2,000 rpm. Three main
bearings. Solid valve lifters. Single downdraft
carburetor.

CHASSIS DATA: Wheelbase: 89 in. Overall
length: 155 in. Height: 57 in. Width: 60 in.
Front thread: 49 in. Rear thread: 48 in.
Standard Tires: 5.50 x 15.

TECHNICAL: Layout: rear engine, rear drive.
Transmission: four-speed manual. Steering:
rack and pinion. Suspension (front):
independent coil springs. Suspension (back):
independent with swing axles and coil
springs. Brakes: front/rear disc. Body
construction: steel unibody.

PRODUCTION DATA: Sales: 18,432 sold in
U.S. in 1964 (all types). Manufacturer: Régie
Nationale des Usines Renault, Billancourt,
France. Distributor: Renault, Inc., New York,
NY, U.S.A.

Serial number: R-10950059799
Engine Number: Type 670-05 #191563
California License Plate number: UOU 087
Vehicle ID Number: 0059799
(For R.R.V.)
Los Angeles, California
January 15, 2000, 2000
Gelatin-silver print, edition 5/10
11 x 14 inches (27.9 x 35.6 cm)

MEGAN WILLIAMS
Stirring Up Dust, 1994
Charcoal and pastel on paper
26 x 20 inches (66 x 50.8 cm)

Pumpkin Heads, 1995
Oil on linen
60 x 48 inches (152.4 x 121.9 cm)
The Museum of Contemporary Art,
Los Angeles
Purchased with funds provided by Dean
Valentine, Blake Byrne, A. G. Rosen,
Alan P. Power, and Carol Vena-Mondt and
Nowell J. Karten, 96.6

PAUL WINSTANLEY
Veil 6, 2000
Oil on linen
68 x 64 inches (172.7 x 162.6 cm)

BRUCE HELANDER *Angel's Ajar*, 1994

GEORGE STOLL *Untitled #2 (Tupperware)*, 1996

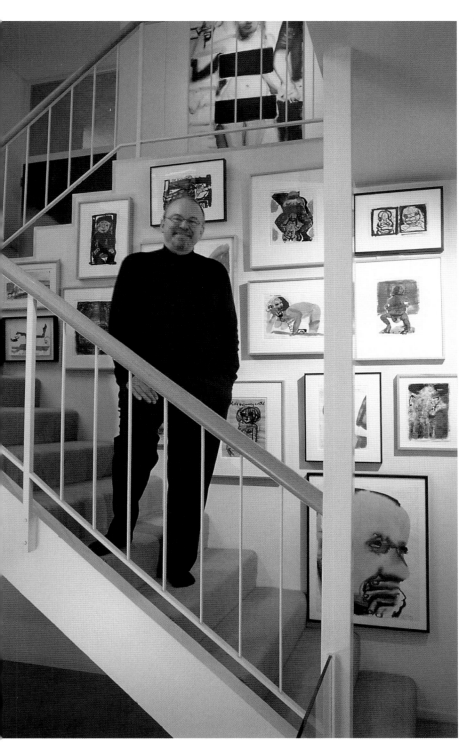

When I started to collect art, I had no idea that one day my collection would be wanted by an art institution, let alone MOCA, which I believe possesses one of the great contemporary art collections in the world.

As a collector, there has been no greater joy than to select and live with wonderful, meaningful, and beautiful works of art created by artists who have chosen this medium as their means of communication. It has certainly expanded my interests and deepened my understanding about life! In addition, I have had the joy of knowing and befriending hundreds of people in the great world of art. I thank them all for making my life richer.

I am so happy to share my collection with Los Angeles and hope you will enjoy it for years to come.

Blake Byrne
Los Angeles, 2005

BLAKE BYRNE at home, Los Angeles, 2005

This publication accompanies the exhibition
"The Blake Byrne Collection," organized by
Ann Goldstein and Michael Darling and
presented at The Museum of Contemporary Art,
Los Angeles, 3 July – 10 October 2005.

"The Blake Byrne Collection" is made
possible with the generous support of Brenda Potter
and Michael Sandler and UBS.

Director of Publications: Lisa Mark
Senior Editor: Jane Hyun
Editor: Elizabeth Hamilton
Administrative Assistant: Theeng Kok
Designer: Peter Willberg
Printer: Litho Acme / Transcontinental, Montréal, Canada

ISBN 0-914357-90-5

Library of Congress Cataloging-in-Publication Data

Museum of Contemporary Art (Los Angeles, Calif.)
The Blake Byrne Collection / organized by Michael Darling and Ann Goldstein.
p. cm.
Accompanies an exhibition of artwork in the Blake Byrne collection
of the Museum of Contemporary Art, Los Angeles,
3 July–10 October 2005.
ISBN 0-914357-90-5
1. Art, Modern—20th century—Exhibitions. 2. Byrne, Blake—Art collections—
Exhibitions. 3. Art—Private collections—California—Los Angeles—Exhibitions.
4. Museum of Contemporary Art (Los Angeles, Calif.)—Exhibitions. I. Darling,
Michael. II. Goldstein, Ann. III. Title.

N6487.L67M886 2005
709'.04'17479494—dc22

2005047930

Printed and bound in Canada

Photo Credits

Photo: Brian Forrest, front cover, pp. 8, 15–16, 19 top, 22, 24 left,
27, 31–32, 34–35, 40, 45, 49–50, 52–53, 58, 60, 67, 70–72, 74, 76, 78,
86–87; Photo: Adam Reich, back cover, p. 37; Courtesy of the
artist, pp. 18, 44; © 2005 Artists Rights Society (ARS), New
York/ADAGP, Paris, photo: Susan Einstein, p. 23 right; Photo:
Simon Vogel, p. 25; Courtesy Margo Leavin Gallery, Los Angeles,
pp. 69, photo: Douglas M. Parker Studio, p. 29; Art © Lynda
Benglis / Licensed by VAGA, New York, p. 31; Art © The Joseph
and Robert Cornell Memorial Foundation / Licensed by VAGA,
New York, p. 32; Photo: Paula Goodman, p. 33; Courtesy Galerie
Chantal Crousel, Paris, p. 42; Courtesy Acme, Los Angeles, p. 46;
Courtesy Zwirner & Wirth, New York, p. 47; © 2005 Joseph
Kosuth/Artists Rights Society (ARS), New York, photo: Brian
Forrest, p. 48; Courtesy Marian Goodman Gallery, New York, pp.
56–57; Courtesy of the artist and Metro Pictures, New York, p. 68;
and © 2005 Andy Warhol Foundation for the Visual Arts/ARS,
New York, photo: William Nettles, p. 76.

Front cover: **MIKE KELLEY** Detail of *The Monitor and the Merrimac*, 1979
Back cover: **ROBERT GOBER** *Untitled*, 1998
Frontispiece: **JUAN MUÑOZ** *Shadow Figure*, 2000